Painting
STILL LIFES

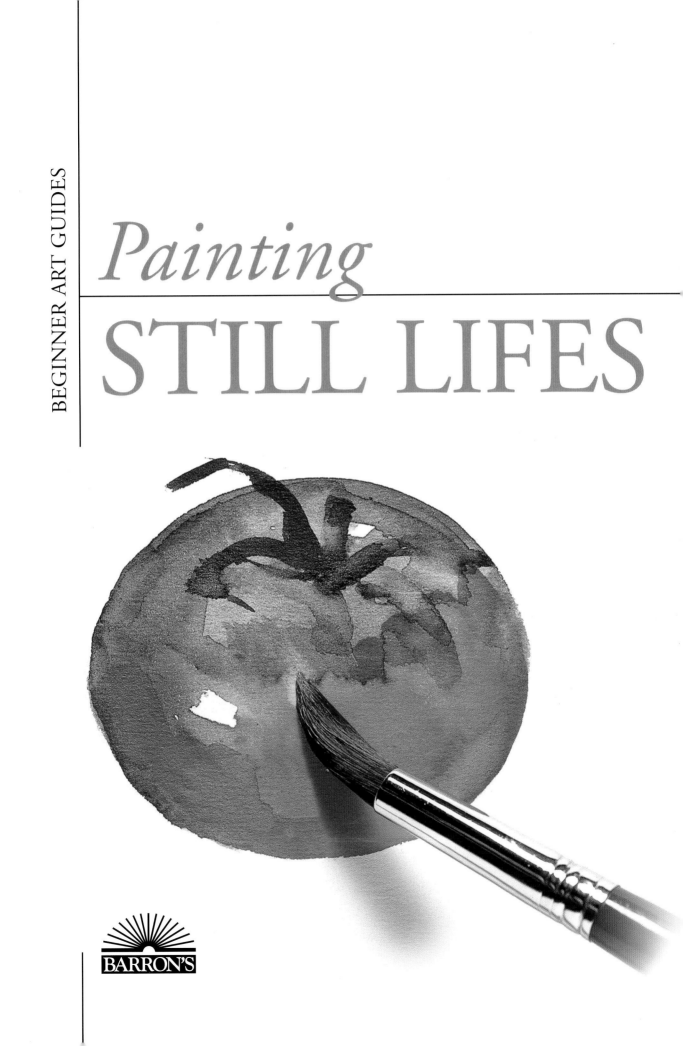

BARRON'S

First edition for the United States, its territories and possessions, and Canada published in 2007 by Barron's Educational Series, Inc.

© Copyright of the English edition 2007 by
Barron's Educational Series, Inc.
Original title of the book in Spanish: *Guía Para Principiantes: Pintura de Bodegón*
Copyright © 2007 by Parramón Ediciones, S.A.—World Rights
Published by Parramón Ediciones, S.A., Barcelona, Spain

Authors: Parramón's Editorial Team
Text: Gabriel Martín Roig
Exercises: Almudena Carreño, Gabriel Martín, Esther Olivé de Puig, Manel Plana, and Óscar Sanchís
Photography: Estudi Nos & Soto

English translation by Michael Brunelle and Beatriz Cortabarria

All inquiries should be addressed to:
Barron's Educational Series, Inc.
250 Wireless Boulevard
Hauppauge, NY 11788
www.barronseduc.com

ISBN-13: 978-0-7641-6049-3
ISBN-10: 0-7641-6049-4

Library of Congress Control Number: 2007922254

Acknowledgments
Our thanks to the Escola d'Arts i Oficis of the Diputación de Barcelona, to Enric Cots, Josep Asunción, and Gemma Guasch, as well as to the students Montserrat Carbonell, Montserrat Castellà, Enrique Clapers, Teresa Diego, and Carin Llauradó, for their support and collaboration in the execution of the exercises in the section "Work by Students."

Printed in Spain

9 8 7 6 5 4 3 2 1

CONTENTS

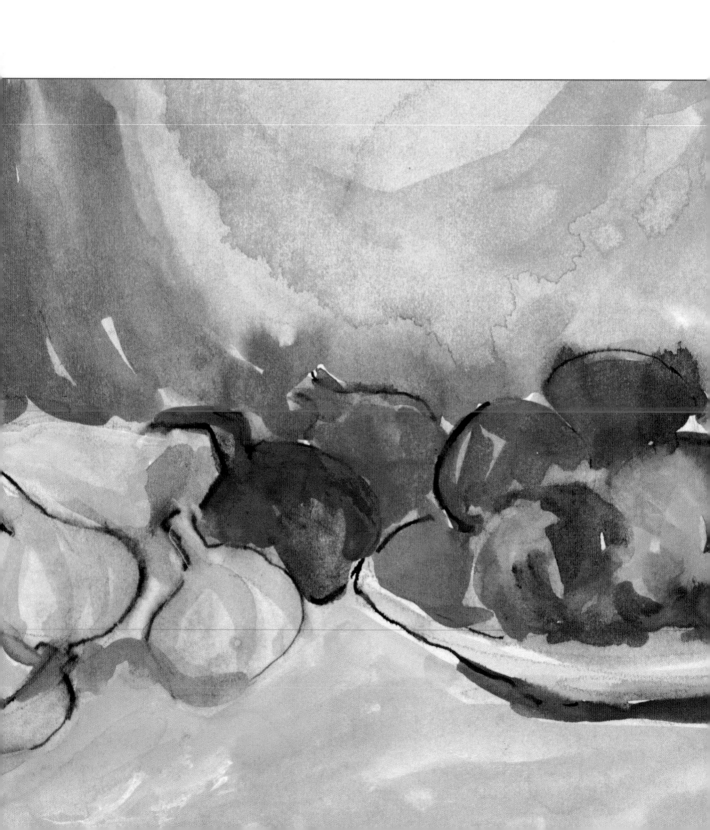

The MODEL Within REACH

Still life is a pictorial genre that depicts groups of inanimate objects, undertaken either as a technical exercise or artistic expression, that attempts to give them a symbolic, spiritual, or life significance that goes beyond the representation of the figures.

It generally consists of a composition made of objects seen from a short distance, normally a close-up view, over a non-descriptive background, or as figures in an interior scene.

The most commonly represented still life objects, other than a few variations that reflect to the time in which or to the different countries where the genre was cultivated, are usually flowers, fruits, vegetables, ceramic, glass and metal pieces, cloth, furniture, and game, among others. Although these components are related to the oldest and most academic types of still life, in today's world, artists resort to any common daily life object: kitchen utensils, food, stacks of books, electric appliances, wrinkled clothing, even some disposable objects.

From the educational point of view, still life offers many opportunities when compared to other genres. First of all, this is the best technique for learning how to lay out the objects and the elements on the surface of the painting. Despite the apparent limitations of the subject matter, one can achieve a great variety of compositions, with the same few objects. This requires selecting the objects and arranging them as desired, while considering coherence and balance.

Since a still life can be painted indoors, it gives the artist complete control of the model; this means that light can be controlled and the objects can stay in place, unchanged for a long time. Therefore, it is ideal for those who are looking for the freedom to work at their own pace, with all the time in the world to experiment with different techniques and interpretations.

So, all the odds are in your favor. No wonder this has been the most commonly practiced genre through the history of painting, for its simplicity and its possibilities at all levels. It is an interesting testing ground for improving composition and mastering techniques.

The LANGUAGE of

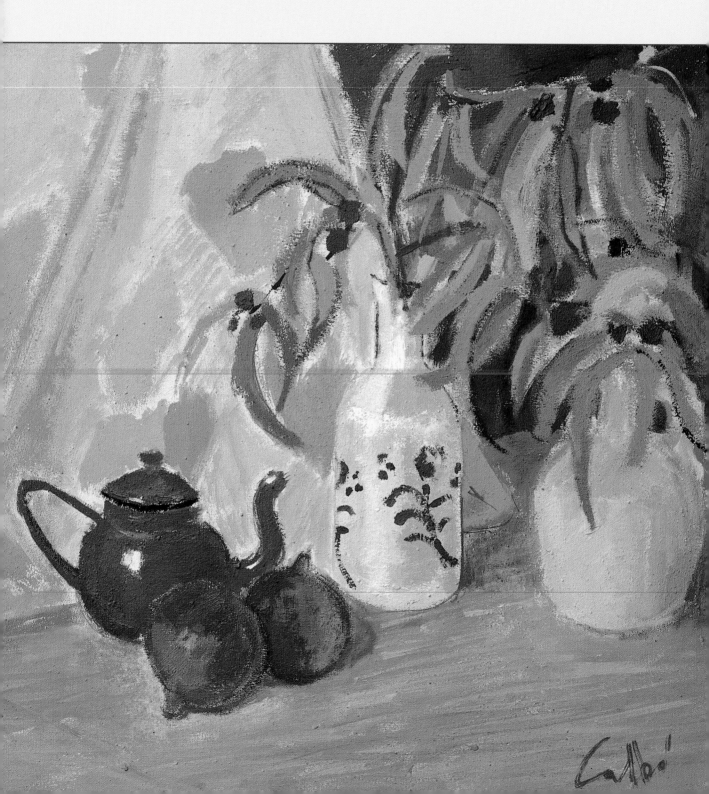

FORM *and* REPRESENTATION

The LANGUAGE *of* FORM *and* REPRESENTATION

I t is the first model that is used as a reference when one begins to learn art, mainly because the still life form is an excellent testing ground for those learning how to use the different elements of pictorial language—form, color, space, texture, and approach— to convey precisely what moves a person to paint.

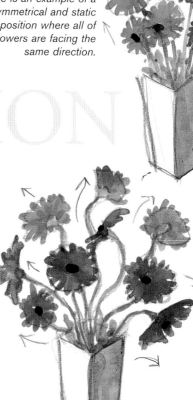

Studying the
COMPOSITION

Before you begin to paint it is important to learn how to set up the composition—in other words, how to arrange the elements of the painting to achieve a pleasing ensemble. Even though there are no sure formulas for creating a balanced composition, the principles of unity and variety are vital to the creation of any successful still life.

Selecting the Objects

The elements chosen should have pleasing designs that go well together and that have affinity and consonance with regard to style, quality, and function. Objects with very complicated adornments should be avoided. Then, they are arranged in a narrative way that clearly explains what they are.

Careful with Flowers

If you decide to work with floral still life, the flowers should be arranged in a way that looks natural and informal. Try staggering them with their blooms facing in different directions. Usually, symmetry and balance are not desirable concepts for drawing or painting floral arrangements.

Since the nature of still life is already static, rhythmic movement should be promoted by trying to arrange flowers facing different directions.

ARRANGING THE ELEMENTS

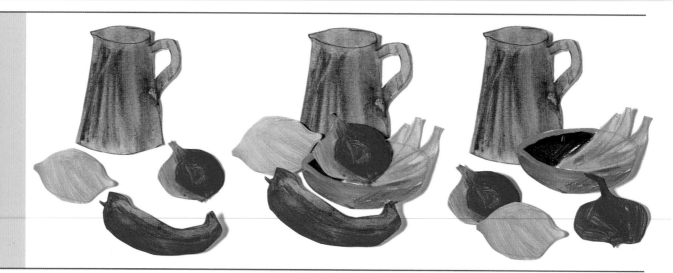

The greatest mistake in the arrangement of objects in a painting is for them to look isolated or too far apart from each other.

Too many objects grouped closely together in the center of the painting make the composition look too rigid and ruin the results.

In correct composition, the objects are not placed too close together. Asymmetrical groupings offer more variety, making them more appealing.

Tip

Objects should be grouped together in layers to give the composition some depth and to leave some in the foreground.

Unity and Diversity

One of the most important goals of a composition is to create visual balance through unity. This is achieved by introducing some elements that are related to others. This visual link is very useful because objects that go well together are more pleasing than ones that do not. Unity should be in balance with diversity and this is created by putting some object out of place, promoting asymmetry and contrast between lights and shadows, textures and colors.

Studying the Point of View

Before you begin to paint, it is important to observe the arrangement from a distance, trying to see it as a puzzle of intertwined forms, colors, and tones that conform to a balanced composition. Choose the best possible point of view by making several preliminary studies or sketches that will help you select the position and layout that will eventually be adopted.

When several objects are placed on a table you should not limit your view to the way the model looks from the front. Walk all around it and study the various points of view offered to decide which one is the most appropriate to achieve the look you want.

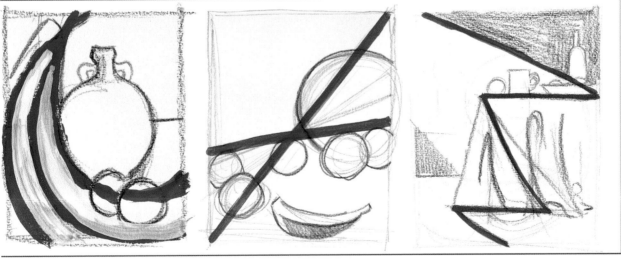

A classic way to create surprising compositions is to arrange the elements following imaginary lines that determine the placement of the forms.

A diagonal composition is the simplest and most effective one. The diagonals that go across the canvas suggest depth in the painting.

The still life should be laid out forming compositional lines. When drawing it, some objects should be moved to coincide with the lines, as is the case in this zigzag arrangement.

IDENTIFYING COMPOSITIONAL LINES

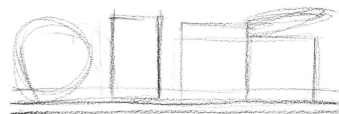

LAYING OUT
and Planning

The best way to "strip" a still life is to try to see it in its most simplified form, and then reduce it to a composition of simple geometric figures.

The composition of a still life does not begin when you begin to paint but rather when the elements are sketched on the paper. The arrangement, which may sometimes appear spontaneous and casual, is often the result of a calculated effort and of trial and error. To demonstrate this we are going to study several arrangements and resources.

"Stripping Down" the Still Life

A still life can have many forms, textures, folds, and details that can be distracting. To plan the first block it is important to strip down the series of elements to preserve the main forms, which can then be reduced to simple geometric shapes.

Blocking In Correctly

The elements that make up the still life should be reduced to simple shapes like circles, ovals, squares, rectangles, and triangles. Cylinders and spheres are often used to draw vases, bottles, carafes, and pots. When an object that you want to draw has a more complex shape, use simple forms that capture the basic essence of the real object to create your sketch.

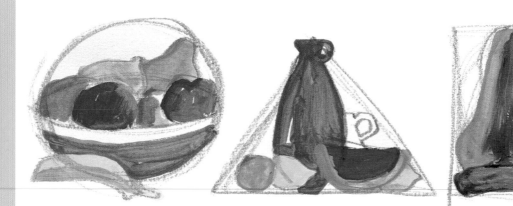

This example is a simple composition, consisting of a still life made of simple geometric shapes. Begin by laying out the objects inside a circular diagram.

By placing the taller objects in the center, you'll create a very symmetrical and balanced composition in a clear triangular layout.

The square layout also provides great stability. To represent the elements you need only a few contrasting color strokes.

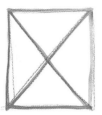

Streamlining the composition, the form, and the colors is the key to properly resolving the layout of the still life. This model is based on two crossing diagonals.

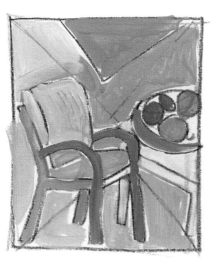

Tip

In charcoal drawings, the spray fixative is often not strong enough to prevent the powder from smearing. This can be prevented by painting over the lines with color that has been heavily diluted with paint thinner or mineral spirits.

Charcoal Drawing and Fixative

When the still life drawing is completely finished, its outlines are redrawn with charcoal (if you are going to paint it with oils) or with graphite pencil (if you are going to paint it with watercolors or acrylics). If the work is done with charcoal, a fixative spray should be applied before you begin to paint, otherwise the charcoal will smear and muddy the colors.

Empty Spaces

The definite forms of the objects are drawn in more detail over the geometric layout. To draw their profiles more easily, be certain to consider the empty spaces between them. When you draw the form of the spaces, you are also unconsciously drawing the forms of the objects. This way, the spaces and the forms are unified and the same relevance is given to all of the pieces of the puzzle within the limits of the format.

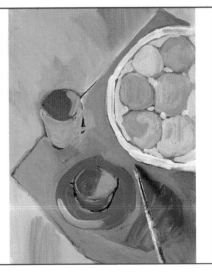

If you take into consideration the internal forms of the still life, that is, the silhouettes formed by the empty spaces, the representation will be more credible and proportionate.

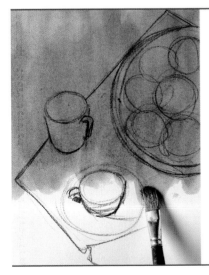

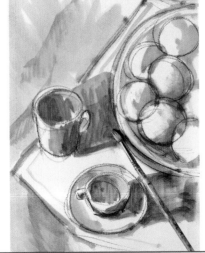

The first order of things for the still life artist is to cover the white canvas. This is achieved by filling up the space with very diluted paint, using a lot of paint thinner.

Another way of approaching the still life is to leave the lighted areas unpainted and cover the shaded areas with brownish colors mixed with mineral spirits. Other colors are added later.

The third way is to apply a base of saturated and flat colors. Then, over this base, each tone can be shaded to make it look closer to the real model.

CREATING RHYTHM

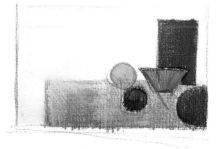

The rhythm in a still life is achieved by creating tension through composition, by breaking symmetrical layouts, and moving the elements to one end of the painting.

Given the fact that a still life is basically static, it is essential to compose it in a balanced manner, in such a way that the elements convey sufficient rhythm and energy to maintain the interest of the viewer. But, how is this achieved?

What Is Rhythm?

Rhythm in a still life painting is provided by distributing the elements in a manner that provides surprise, contrast, repetition and tension, compensating for the lack of interest created by a static composition.

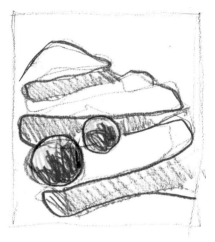

Different Ways of Creating Rhythm

Rhythm in a painting is important because it directs the viewer's eye across the surface of the piece. During the painting process the artist can introduce certain effects that highlight the painting's sense of rhythm, such as crossing several elements in the foreground, highlighting or extending the shadows projected by the objects, or including fabrics that have wrinkles and folds.

Folds or designs on fabric are a common method of introducing rhythm in a static composition.

A GESTURAL PAINTING

In gestural painting, spontaneous and large lines are used to capture the essence of the objects. We begin by painting the vase with a single rhythmic line.

We finish it with another violet spiral brushstroke. Two additional green and dark blue brushstrokes that cross each other are used to paint the flower stems.

The flowers are painted with several colors and wavy brushstrokes. In this piece, spontaneity comes from moving the forearm vigorously, forming rhythmic and dynamic lines.

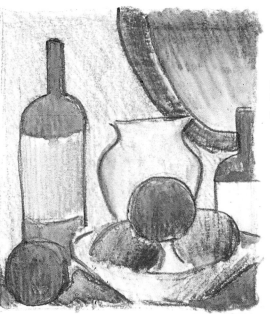

Colors can be arranged on the model according to a set plan. The design on the left is applied to the drawing on the right with a very rhythmic distribution of color.

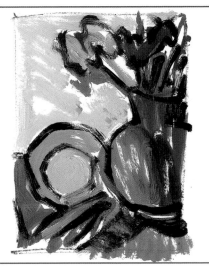

Repetitive brushstrokes aligned in the same direction add an interesting rhythmic element to the painting.

Arabesques

The drapery integrated in a still life is an endless source of curves and arabesques that enhance the rhythmic effect of the model. The rhythm of the folds, the repetitions, the zigzags, and their comings and goings create an attractive linear configuration that provides movement and tension to the composition.

Rhythm with Color

Color can also become an inductor of rhythm, if it appears in contrast and spreads through the entire painting, either randomly or following a scheme, to connect the different elements. The color effect is more real if the paint is not overly integrated into the background and does not have sharp edges that make it look more like forms.

Rhythm with Brushstroke

Repeated forms or brushstrokes establish a rhythm that creates a unifying effect on the work. This can be translated into the support by inscribing quick and spontaneous movements of the hand that flow well, or through the systematic repetition of brushstrokes that are all applied in the same direction.

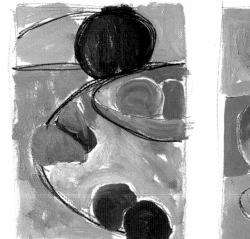

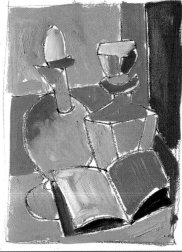

Here are three different ways of creating rhythm in a still life. The first one consists of organizing the objects to form curves or various geometric shapes.

When the model is interpreted through geometric shapes, the straight lines and right angles involved convey a sense of rhythm to the surfaces and the contours.

The third approach is to focus on line. By emphasizing the contours of the objects with a black line, they show greater contrast and are more dynamic.

COLOR
Schemes

COLOR *Schemes*

Uniformly applied paint can be used to suggest flat surfaces evenly bathed with light.

Still life offers great freedom in terms of composition and also in terms of color harmony. Color selection is important for creating the mood of the painting. Colors that are soft and low in saturation produce an intimate feeling, while the very bright ones that contrast with each other create an expansive mood.

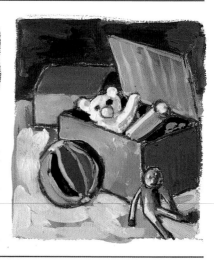

Gradations make it possible to describe rounded surfaces unevenly bathed with light, in other words, to represent volume.

Harmonious Scheme with a Dominant Color

The harmonious scheme shows how one color has a clear influence over the rest of the colors. In a monochromatic color scheme, a single color is mixed with black or white to darken or lighten it. In a harmonious color scheme, a base color is chosen and all the rest are created from it; the base color is mixed with others to produce different color nuances.

Harmonious scheme with a dominant color. In the center, the base color is surrounded by tonal variations that are in harmony with it.

Color Gradations

To properly represent the volume of the elements that form part of a still life (fruit, vases, bottles, plates, drapery), it is a good idea to apply the paint with gradations. Making a gradation means lightening or modifying a color progressively to represent the transition from the lighted to the shaded areas or vice versa.

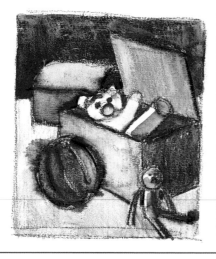

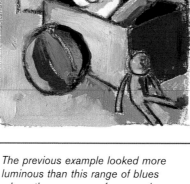

The dominant scheme of blue colors can have different tonal nuances. Let's begin by comparing a range of blues in contrast with a range of magenta colors.

The previous example looked more luminous than this range of blues where the presence of gray and green undertones gives a cooler look to the piece.

Warm colors regain relevance when the range of blues is changed to violet and pink tones. The three examples offer different psychological perceptions.

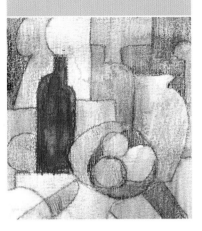

An object painted gray appears to have an intermediate tone when the surrounding color is the white of the paper.

The same object looks much lighter when the surrounding color is dark. This effect is known as simultaneous contrast.

Simultaneous Contrasts

If an object that has a light gray color is surrounded by a very dark color, it will appear almost white and vice versa; if a dark one is surrounded by the white color of the paper it will seem darker. This effect is known as simultaneous contrast. It consists of increasing and decreasing color values against the adjacent values. As a result of this effect, the outlines of a still life can be highlighted without the need for enclosing them with a dark line, which often defines the object, making it more rigid.

Contrast with Complementary Colors

Working with complementary colors requires working with opposite colors on the color wheel to maximize the contrast. By placing two areas of complementary colors against each other they appear more vibrant and are mutually enhanced. This color harmony was a common practice among Expressionist painters who used the technique to convey passion and vitality to the viewer.

To paint a vibrant still life with strong contrasts, complementary colors are used. In this case, orange for the areas of light and blue for the shaded areas.

For a harmonious scheme with less contrast, adjacent complementary colors are combined. These are located next to a complementary color on the color wheel.

The colors that you choose will make the result more or less dynamic. They will maintain a harmonious relationship that gives the painting more unity and coherence.

ADJACENT COMPLEMENTARY COLORS

LIGHT *and* SHADE

LIGHT *and* SHADE

The light that comes in through a window creates a dominant scheme of blue colors and shadows with little contrast.

Light and shade are the main resources that the artist has to depict the volume of the objects and the depth of the still life. To a greater or lesser degree, shaded areas are always present in all the models and they create contrasts, highlight forms, and provide unity and coherence to the overall composition.

Light from a Window

If you decide to paint a still life near a window, you will have to deal with the light that comes in through the glass (either with strong contrasts if in direct sunlight, or bluish if over-cast). This can be a problem as light changes and shadows move throughout the day. One solution is to place a light diffuser or a curtain over the window.

Artificial Lighting

Artificial lighting is constant and can be controlled; it makes colors look warmer than they really are. If you place a single source on one side, somewhat elevated, it will normally create a strong light contrast, which helps create solid forms in the still life.

Warm colors are characteristic of artificial lighting, which produces darker shadows with clear and sharp outlines.

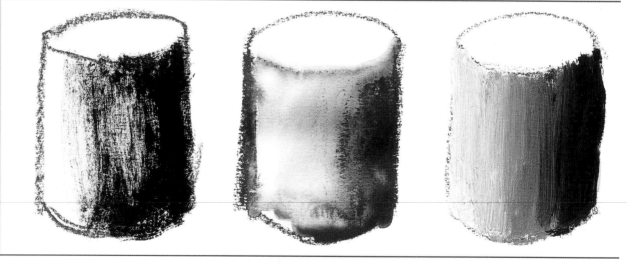

The type of shading says a lot about the quality and texture of the object. For example, shading with the dry brush is suitable for objects with rough texture.

Working with washes is the most common approach for objects with a smooth, shiny, and reflective surface. It works very well for light objects and to create atmosphere.

Gradations with opaque paint that has good covering power make objects look solid and hard. They are commonly used to represent ceramic pieces.

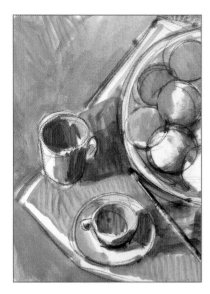

During the first phases of the painting, shading should be applied evenly on all the objects using monochromatic tones. As the painting progresses, you will highlight the most intense shadows and some colors.

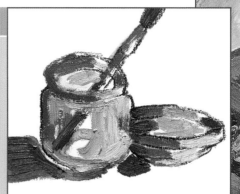

The Phases of Shading

At the beginning the artist must approach all of the objects with a similar color value. The shadows are represented with medium monochromatic color tones. In the second phase, the colors are set apart by applying new colors over the previous ones. The darker areas and the most intense contrasts are left for the third phase.

Light Within the Still Life

Including the source of lighting in the still life produces a very dramatic effect. Light spreads in a radial configuration and casts all the shadows in the same direction. The effect of the expanding light is solved as a tonal gradation that can be emphasized by painting with the brush in the direction of the sunrays.

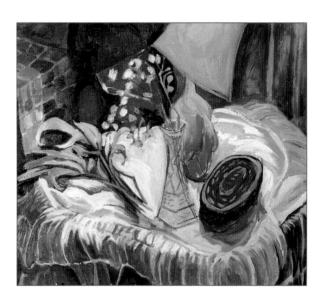

The light source can be included in the still life to achieve a more dramatic effect.

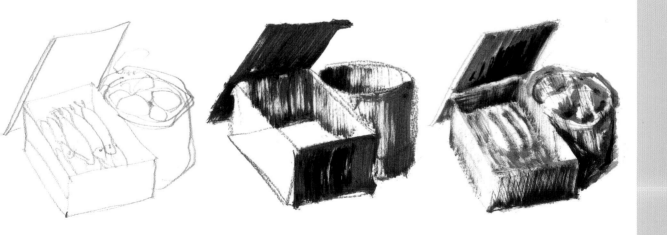

SITUATING THE SHADOWS

If the still life consists of a group of objects you can experiment with colors to create the shadows. Let's begin with this simple drawing to which you will add shadows.

Try to visualize the group of objects as geometric shapes. From shading the flat surfaces you can go directly into representing the volumes of the objects.

Once you have established the angle and the incidence of light, carefully apply the shadows on the drawing in relationship with the source of light.

The previously gradated background shows an irregular distribution of light. It looks more realistic than a background that is completely even.

Different Treatments for the BACKGROUND

Like the sky in a landscape, the background of a still life is very important for displaying the objects grouped correctly. It is not simply a "filler" to complete the gaps. It is important to choose the most appropriate treatment. This avoids emphasizing the background too much and prevents it from becoming the main focus of interest in detriment to the objects.

Even Backgrounds or In Gradation

Objects will stand out greatly against backgrounds painted evenly or with gradations. A solid-color background or an empty and dark area is the most common resource. If you paint the model with a high viewpoint, the surface where the objects are located can work as a background.

Distorted Background

Another common resource for representing a background is to create an out-of-focus view of the room or the study where the objects are located. The best way to work these backgrounds is with washes, dense colors diffused with each other, or through brushstrokes with a dry brush. Colors and forms can be made out, but never the objects or their details.

When we apply a wash, the background appears to be out of focus. The diffused contours of the furniture and the interior are in contrast with the sharp lines of the nearby objects.

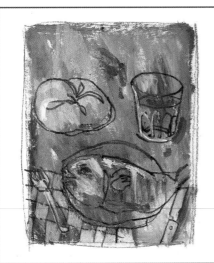

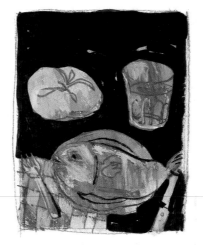

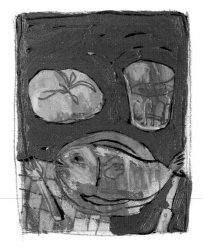

The dramatic nature of the still life poses a typical problem of the genre: the relationship between the background and the figure. Let's look at three examples. The first one is painted in monochromatic tones.

If you decide that the objects will convey the message of the piece, they need to be isolated in terms of color. Paint the background black.

Since black takes away the color's impact, we resort to the complementary of green for the background. Red does not darken the background too much and highlights all the forms.

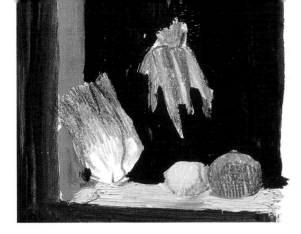

Tip

Using decorative papers or patterned fabrics, a very common practice in colorist still life, is ideal for making the piece lively and enhances the dynamic feeling of the surface.

A black background makes the objects of the still life more colorful. They become more defined as a result of the contrast.

Black Background and Fabric with Folds

A black background adds luminosity to the objects in the still life, thanks to simultaneous contrast. If, on the other hand, you wish to make the background look somewhat three-dimensional, you can place a piece of fabric behind a group of objects. If the fabric hangs, forming folds, it will provide a line structure that enhances the painting.

Expanding the View with a Mirror

When the painting is elaborate and ambitious, the artist can expand the depth of the still life's background by placing a mirror immediately behind the model, so that the pieces will be reflected on its surface. A similar effect will be achieved by placing the model in front of a mirror.

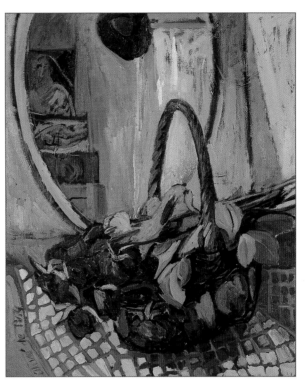

Placing a mirror immediately behind the still life gives greater depth to the model.

The contrast between textures is very important when drawing objects. However, keep in mind that when the background has a pattern, the object should have a solid color.

On the other hand, if you are going to paint objects with decorative elements, the background should be solid or have gradations. If not, the painting will look too busy.

For an object with a solid color to stand out against a graded background, it's best not to put the areas with similar tones together. To avoid this, the object could be painted with the opposite gradation.

CONTRAST BETWEEN OBJECT AND BACKGROUND

To paint the surface of metal objects, you should combine brief gradations with areas that have high incidence of light.

The TEXTURE of Objects

Still life painting provides a wonderful opportunity to study the surface quality of the materials. The texture often constitutes the essence of the still life, especially when the objects are selected based on their different surfaces. However, the depiction of textures tends to present added complications that we will try to explain very simply and clearly.

The Transparency of Glass

Painting glass can be difficult if the person is not familiar with the graphic effects required to represent it. Given that this is a transparent material, the easiest way to suggest it is to draw what is behind the object with the proper distorted effects created by the shape and the color of the glass. This material is characterized by having the lighter areas of color concentrated in the center while the edges are darker.

Painting Metal

The color of the metal objects that the artist may come across in his or her still life repertoire can be painted by simulating the sparkle and reflections. These reflections are the result of a clever and sharp combination of very light and very dark areas that should be resolved by taking into consideration the overall object and the direction of the line, which must go along the convex surfaces that metal objects often have.

Glass objects have one area that is more illuminated in the center and another on the base; the edges have a darker color.

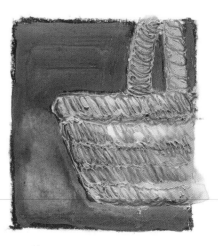

When working with oils the texture of the objects can be highlighted with a simple sgraffito. The characteristic grain of wood, for example, can be created by simply drawing on the paint with the handle of the brush.

When a piece of material has a pronounced fold or wrinkles, the weft of the fabric is resolved with soft sgraffito, which emphasizes every fold.

The texture of objects made of wicker material is represented through a series of very geometric brushstrokes that are repeated over the entire surface of the object.

It is a good idea to practice drawing different types of drapery separately to be able to understand how, and in which direction, they fold.

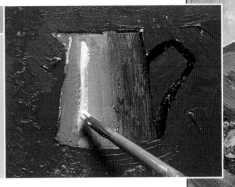

Tip

Objects that have polished, glossy, or shiny surfaces act as mirrors that reflect light in the form of white areas of color.

Wood, Folds, and Wrinkles

The color of the wood is painted with gradations of gray, ochre, and sienna. Then, the characteristic grain and knots of the wood are painted over this surface with a thin, round brush. It is important to make them clearly visible since this is the distinguishing characteristic of this material. The series of folds and wrinkles in fabrics that are often incorporated into still life is known as drapery. It is considered a true abstract representation of lines, light, and shadows and as such it has a high compositional and decorative value. The volume of the folds is achieved through gradations and by contrasting light and shadows. The areas of the folds that stand out the most are the lighter tufts, while the inner part of each fold will be the darker ones. There should be a gradation between these two areas.

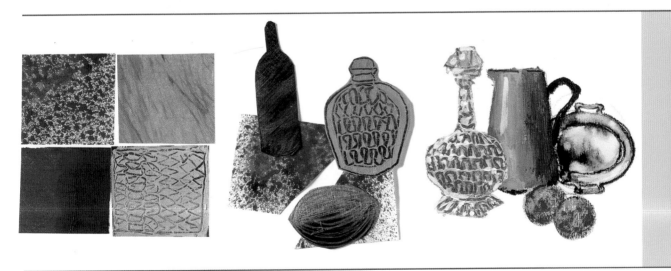

EXPERIMENTING WITH TEXTURE

Different texture effects can be achieved by applying the paint in different ways. Shown here are a series of textures made on several pieces of paper for the purpose of comparison.

Here, the textures are reproduced on larger paper. Different objects chosen for their texture are cut out and put together, forming a composition.

Finally, the textures practiced on the paper cutouts are incorporated into a real painting made of objects with very different textures.

21

The BASIC STRUCTURE

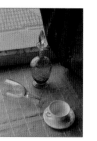

Just as the human body has a skeletal structure that is not visible but holds it together, a painting can be constructed from a framework that supports the structure and gives the paint meaning and a sense of solidity. This is achieved with thick color lines that cover the drawing, forming a sort of net that defines the areas of color as if it were a stained glass piece. This exercise was painted with mixed media by Gabriel Martín.

1. The support is covered with a layer of orange acrylic paint and the model is loosely drawn with a pencil. The forms are then marked with a round brush and bright red acrylic paint.

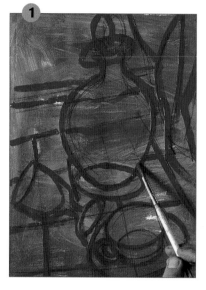

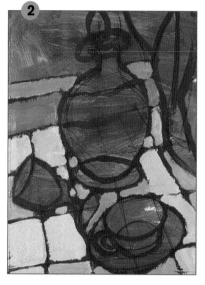

2. Once the acrylic base has dried, the plaid tablecloth is painted with a range of blue tones mixed with a large amount of white. The red structural lines show through between areas of color, holding the drawing together.

3. The frame, the window glass, and the curtain (the latter with colors containing less white) are depicted with more or less regular blotches of color. Working with pastel tones or colors mixed with white paint extends the paint and reduces its saturation.

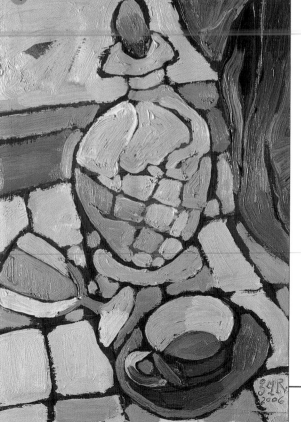

4. Painting the objects using warm colors creates greater contrast with the blue scheme of the tablecloth. The texture of the bottle is created by making reserves of a series of lines through which you can make out the background. In the finished painting you can see how the first original lines provide coherence to the piece.

The CHIAROSCURO EFFECT

Chiaroscuro is used in still life to represent contrasts between the most illuminated areas and the darker ones to highlight the effect of volume. This is not only a method for representing one or several areas of the model but an approach that takes into account the overall space of the piece. This method involves light, contrast, and character. Here is a monochromatic example painted with acrylics by Gabriel Martín.

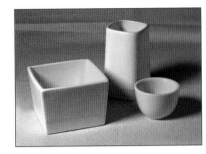

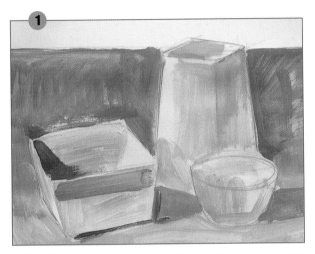

1. The first shadows are painted with very diluted grays over the pencil drawing. Working in blocks or areas establishes the first differences between light and shadow.

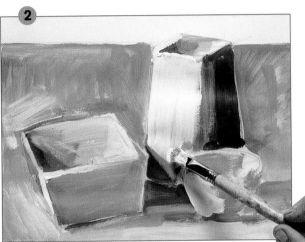

2. Next, contrasts are applied between the areas of light and shade with absolute values, making the darker shadow very dark and the white pristine, and very light. Intermediate values are created with gradations.

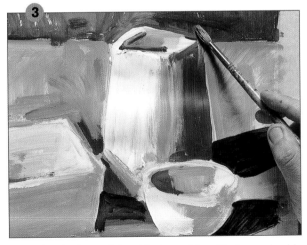

3. As the shadows of the objects are intensified, you should also do the same with the background. This helps the figures stand out against the dark background.

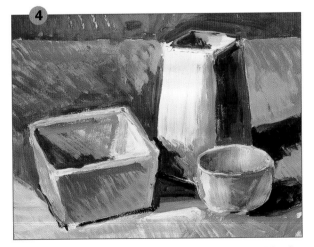

4. Each shaded area has its own value that does not blend with the rest of the values, but establishes the exact degree of light in that area of the composition. This way of working helps the clarity of the painting since the outlines are sharply defined as a result of the contrast between values.

With pieces of colored paper arranged as a collage, you can make a quick still life composition.

The Advantages *of* SYNTHESIS

The possibility of playing with the forms and the areas of color without being excessively tied to the shapes of the objects allows the artist to take full advantage of the opportunities offered by synthesis. In this process, the artist should follow his or her instinct and perceptive ability to simplify the basic forms of the model.

Then, you can adjust or modify the contours with lines that make the objects recognizable.

Simplification Process

The best way to simplify a still life is by trying to see it as if it were made of flat objects, like pieces of a collage. The next step consists of simplifying the contours even more, in such a way that the forms look geometric.

Contrast Is Fundamental

When the forms of a still life are synthesized, colors become more relevant. This conditions the perception of the forms, increasing or decreasing the contrast to increase or reduce the differences between the elements of the piece. In the synthesis process, contrast is a powerful tool of expression, a way to intensify the meaning of the image, making the message more readily available. Differences are emphasized through contrast.

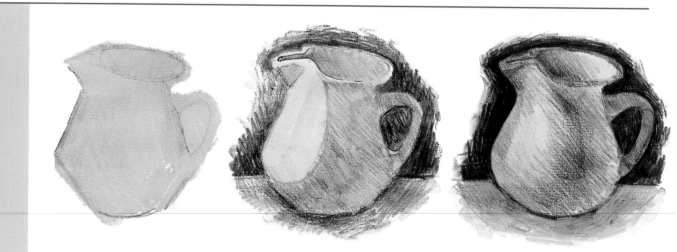

Synthesizing helps represent a still life in a realistic way. It is necessary to represent the general form first. Here it is painted with solid yellow.

From the previous form the background and the table are painted, and the lighted area is defined from the shaded one. The approach continues to be very generalized.

Once the object is established it can be defined by creating gradations with the shadows, making the orange darker, painting the contours and the handle green, and darkening the background.

When the work is synthesized, it is a good idea to catch the attention of the viewer with emotional tension created by strong contrasts or by breaking the continuity of the lines.

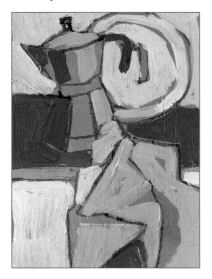

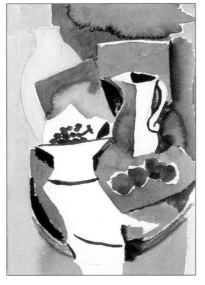

Constructing the still life using flat areas of color enhances the synthesis. This approach eludes details and the nuances of shading.

Tip

A good way of synthesizing the objects in a still life is to construct them with superimposed geometric shapes.

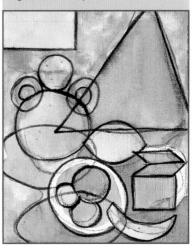

Looking for Tension

The main reason for creating contrast between colors and textures is to enhance the perception and the understanding of the image. These contrasts create a point of tension in the painting that captures the attention of the viewer. When a still life lacks expression, you should ask yourself where the tension factor is. These cases can be resolved by introducing color, texture, chiaroscuro, and compositional contrasts.

Flat Paintings

Working with applications of flat color facilitates the synthesizing process since you resort to a single tone to explain a surface full of values and shades. Flat colors lack tonal variation because there is no modeling involved. Although you should not apply this approach very strictly, a flat application of color can help represent subtle chromatic variations.

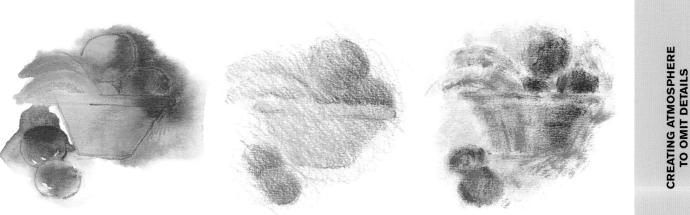

CREATING ATMOSPHERE TO OMIT DETAILS

Atmosphere, which blurs the outlines and eludes details, is another way of synthesizing. This is done by wetting the paper before the washes are applied.

In this example done with color pencils, the atmosphere gives body to the air, making it visible. The blurry approach conveys an intimate feeling to the scene.

To achieve atmosphere with oil or acrylic paints, painting is done with a dry brush. This way, the values are blended with each other and the light and shadow are alternated in a continuous and fluid way.

REALITY *and* Plastic Art

If we pay careful attention to the composition of the objects and to the harmony of the colors it is because artists have a very determined view of aesthetics, a view that should prevail in painting beyond any realistic interpretation. Painting a still life does not mean copying it as if it were a photograph.

The Triumph of the Personal

When still life painting began, artists were very interested in imitating the model and painting it very realistically. With the arrival of Impressionism and the success of photography, artists began to abandon the realistic and academic approach in favor of a more personal and unique view. Adapting the model to the personal view of the artist is known as interpretation. Interpreting means emphasizing the form, colors, and qualities of the elements that compose the still life to achieve a very personal representation that expresses the creative freedom and the personality of the artist. An interpretative approach has no specific rules; every painter follows his or her own instinct and improvises solutions as he or she paints.

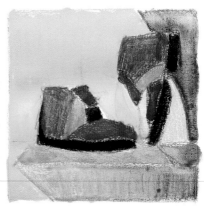

To interpret a still life, we must abandon photographic representations of the model and try to see it through brushstrokes, colors, and expressive distortions.

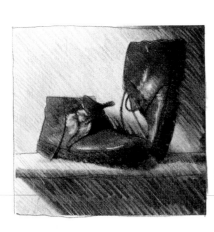

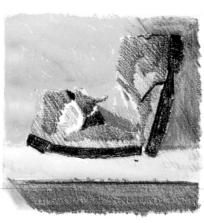

To understand how interpretation should work, we are going to demonstrate the process of abstraction beginning with an overly realistic representation of a pair of shoes.

Beginning with the previous model, the first simplification is made by cleansing the forms. Change the colors and eliminate some of the details as you see fit.

This requires more than just a representation that does not resemble reality. The artist must decide which aspects should have the most relevance and which colors should be emphasized.

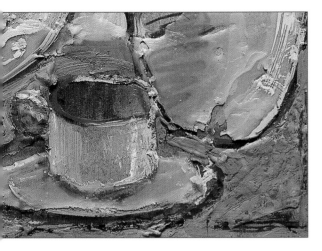

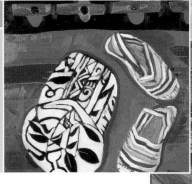

Tip

The way colors are used plays an important part in offering a personal view. This is why the artist should have a very personalized style and palette that is easily recognizable in his or her paintings.

It is important to find original compositions—even if this requires eliminating some elements from the still life.

Surprising Compositions and Points of View

This interpretative process must begin with composition. Rather than being satisfied by the natural disposition of the elements, the artist needs to look for the most expressive layout or point of view, cutting out the elements if needed, even when the resulting effect may make the objects represented difficult to identify.

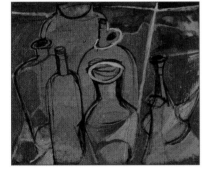

A more personal interpretation can be obtained by changing the colors and creating your own palette.

Exaggeration and Distortion: Key Factors

Interpretation is very closely related to the style used to paint. To make your style more recognizable it is a good idea to emphasize and exaggerate the qualities that make it unique. Another good way to make a style your own is to distort the model at your discretion, changing the relationships between colors by creating your own palette or working the painting with very characteristic brushstrokes.

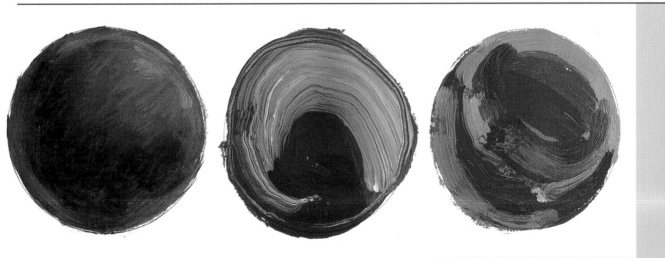

CHANGING THE WORKING STYLE

The working style is the way we apply the colors on the support. Let's compare three examples. The first one is done with very modeled gradations. It is a very academic and formal approach.

The sphere is painted with red paint and with a thick and striated brushstroke of yellow. This approach is very appropriate for synthetic treatments related to modern painting.

This sphere shows a gradation between different colors. The mark of the brush is visible and the shadow looks violet. This way of working can be identified with Fauvism.

The VIBRANCY of LIGHT

Including the source of light as part of the still life is very helpful for creating an intimate and warm atmosphere. The most common approach is to find a lamp with a shade that limits the amount of the light projected and that emits light through the upper and lower parts in such a way that the light beams are clearly defined. If you wish to give the still life a vibrant and expansive look, you can paint the beams of light radiating from the lamp in a circular configuration.

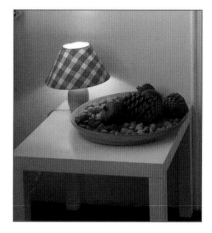

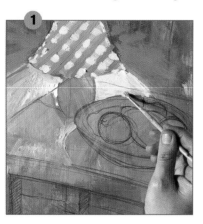

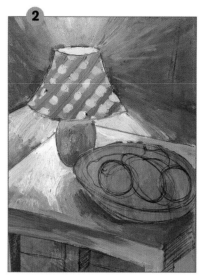

1. The model is drawn over a blue background with a graphite pencil. Then the plaid design of the lampshade is painted with a thin round brush charged with paint mixed with a large amount of white. The illuminated area is painted with yellow that is also mixed with white.

2. A warm color scheme (yellow, ochre, and orange) mixed with a large amount of white is used to represent the light that comes from the lamp. The shadows and the space that protects the shade are painted with very light violet.

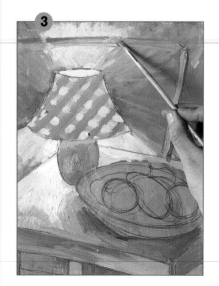

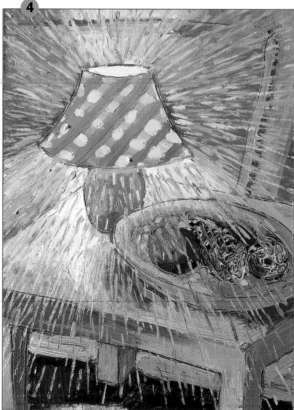

3. The brushstroke should be decisive, applied in the same direction as the light beams. The illuminated areas should have clear gradations with lighter colors near the source of lighting.

4. To paint light beams, you must understand that the light from the lamp expands in a straight line and with a radial configuration. Short and straight lines that flow out of the lamp and cover the entire composition are painted.

INTERPRETATIONS *of a* SINGLE OBJECT

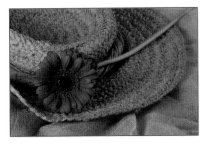

We tend to think of a still life as a group of items, but it is also possible to paint a single object. Of course, the object should offer sufficient reasons to justify this interest. The best way to experiment is to make a series of studies with different colors and interpretations. This exercise was painted with acrylics by Gabriel Martín.

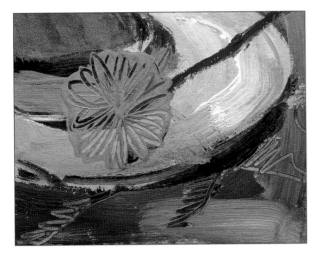

The ellipses of the hat are drawn with a pencil on a piece of paper. Using heavy paint that has good covering power, paint each area very quickly. A red line is drawn over the line of colors for the stem, and you draw some sgrafitto designs on the flower with the handle of the brush.

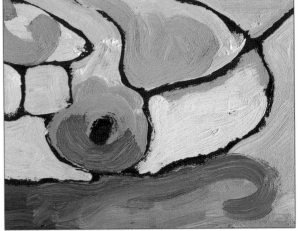

This is a very schematic example. First, the background is covered with red paint. Then, each area is painted with colors that are very reduced with white. The lines that define the profiles become visible when the areas between the colors are left unpainted.

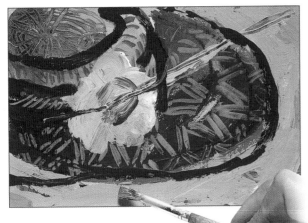

The interest of this study resides in the contrast of complementary colors (red hat against the green background) and in the yellow lines that express the texture. The flower is painted with a single, spontaneous brushstroke.

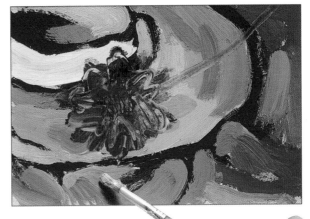

A blue background is prepared, then painted over with ochre and orange colors and tones. The lines that define the hat, the color of the background, are left unpainted.

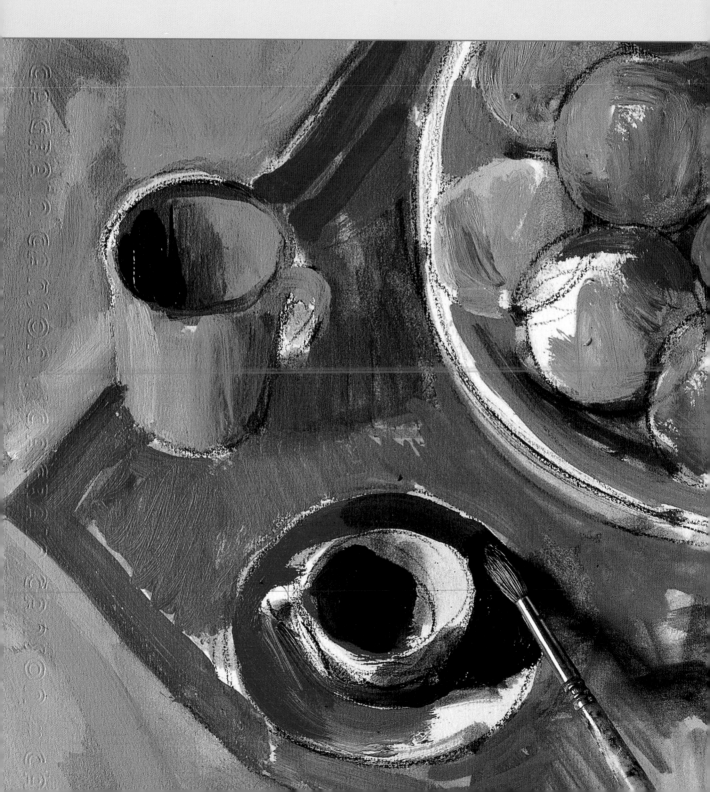

EXERCISES
PRACTICAL EXERCISES

The following practice exercises delve into the specific and practical development of the still life. Each one of the examples that is analyzed summarizes in some way a subject, a technique, a way of working, or a characteristic interpretation that is related to what has been explained in the first part of the book. These are all recurring themes that have been selected for specific applications, always attempting to match the subject with an appropriate technique.

MONOCHROMATIC
Still Life

Still life is very useful for exploring geometric forms and the harmonious relationship between colors. This is going to be our first objective. Even though most of the objects are easily recognizable, the composition must be approached as a series of geometric shapes: rectangles, circles, triangles, and trapezoids that fit together like a puzzle. To focus your attention on the objects, the color palette has been limited to a range of blue colors. This exercise was painted with oils by Gabriel Martín.

Cover the background with a layer of ultramarine blue paint. Next, draw the model with charcoal. As you can see, not all the elements are included and the composition is slightly modified to make it more dynamic and appealing.

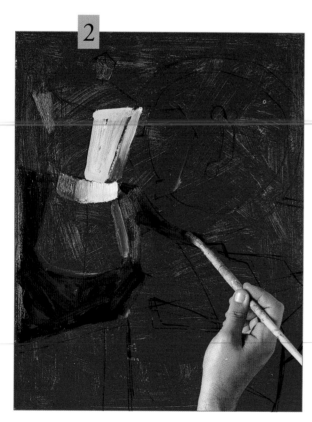

Using white paint tinted with a touch of violet and ochre, apply heavy and opaque paint over the coffeepot to represent the direct effect of the light. The surface of the kitchen is painted with dark violet.

Tip

The range of harmonious blue colors includes blue tones from violet, pinks, grays, and slightly blue whites.

Each area or geometric segment of the coffeepot is painted with an even color, bright violet or blue for the shaded areas, and blue and violet grays where there is more light. When the coffeepot is finished, paint the background.

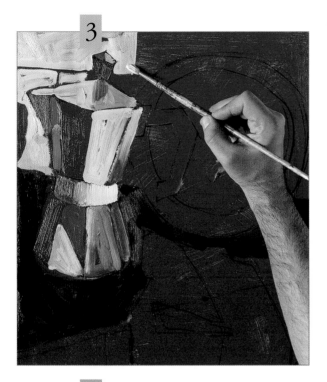

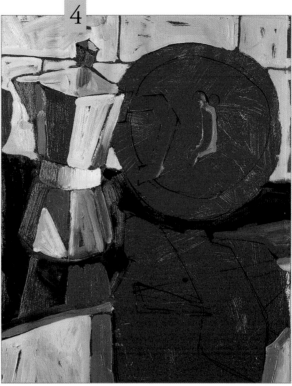

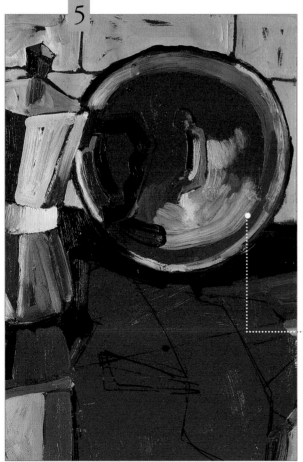

Painting the wall tile is easy. Each square is painted with violet gray, leaving a line unpainted to represent the joints through which the blue of the background can be seen. Use this same gray color to paint the lower portion of the stove.

When painting the metal lid, it is important to clearly differentiate the contrasts between the light reflections (which are painted with blue white) and the shadows (which are left with the color of the background—the initial ultramarine blue).

Using violet mixed with white, paint the reflections cast by the coffeepot on the surface of the stove. Use blue mixed with a generous amount of black to sketch the handle of the coffeepot and outline the contours of the lid. Use violet mixed with a large amount of white to lighten the reflections of the lid.

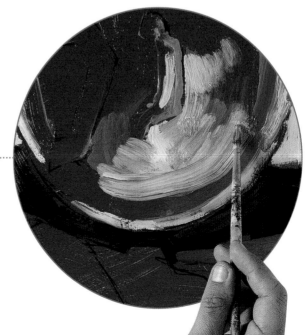

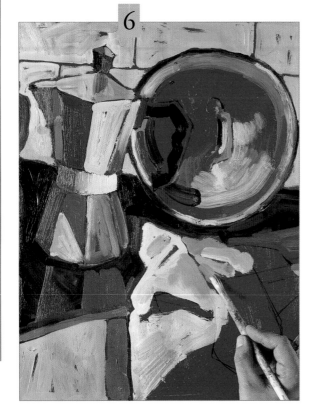

6

Tip

When painting the kitchen towel it is important that the direction of the brushstrokes in the different areas are consistent with the direction of the folds.

The kitchen towel is painted last. The lighter areas are painted with violet whites and grays, establishing a very sharp contrast between the light and dark areas (the blue of the background).

In the finished work, the treatment of the colors and the forms of the objects look quite geometric; everything is painted with a harmonious range of blues and violets. The final touch is achieved by marking several outlines with red lines that highlight the visual appeal of the representation.

Use a piece of soft pastel to draw bright red lines in the areas where the background is visible.

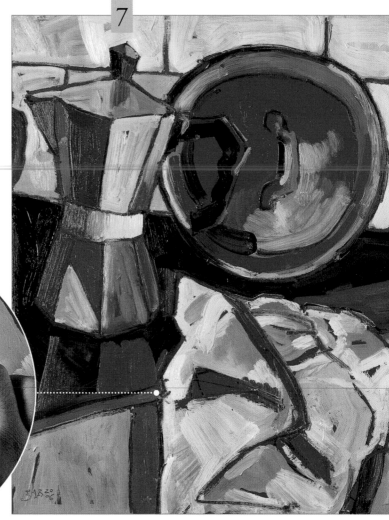

Process of GEOMETRIZATION *and* ANALYSIS

The process of synthesis, geometrization, and selection of colors is not always simple, especially when the subject itself is located right in front of us. Working from sketches or from a previously painted piece makes it easier to engage in the process of geometrization and elimination. Many artists adopt this technique, gradually eliminating elements until the essential form of the object is reached.

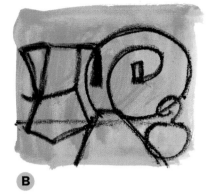

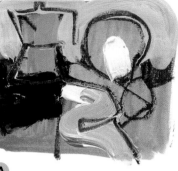

*The first thing to analyze is form. A line drawing creates two representations where geometrization is fundamental. In the first case (**A**), it is important to emphasize the agreement of the structures using a first hint of color. On the second example (**B**), the objects are depicted with a gestural approach; here the lines flow with great dynamism.*

A

B

*The next study is focused on the direction and the quality of light. In both sketches, light comes from the right, although in the first case (**C**), the illuminated areas are represented with light orange, in low saturation, which goes well with the red of the background; in the second study (**D**), the contrast between light (with pure white) and shadow (with black) is sharper, with no intermediate transitions or gradations to soften them.*

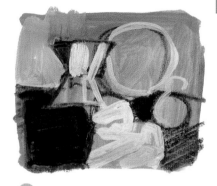

C

D

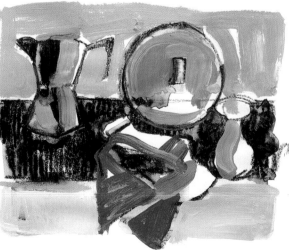

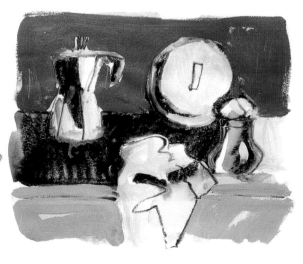

A few areas of color, spontaneous and not very precise, on the objects and the background, offer another option: a harmonious scheme of violet colors. This choice is similar to the one adopted in the step-by-step example, but instead of painting pink tones, that artist has favored blues.

Studying the harmony of the colors doesn't require meticulous work; the application of a couple of flat colors provides a glimpse of how warm colors are harmonized.

Fruit with COLORS

Fruit with Complementary COLORS

Pieces of fruit are traditional subject matter among beginners; their simple structure and the great variety of colors and surfaces they provide entice any artist. Fruit will be the subject of the next exercise, which explores experiments with color. You will paint them using contrasts between complementary colors in areas of light and shadow; this requires changing the color of the real model to adapt it to your needs. This exercise was painted with oils by Gabriel Martín.

A simple composition is established with a line drawing over a brown background. The background was prepared earlier using a layer of acrylic paint to ensure quick drying.

1

2

Tip

The brushstrokes in this example contain only a small amount of mineral spirits. If you choose to use colorist paint to cover the background with brown, it is better not to add mineral spirits to the paint.

It is important to highlight the drawing by painting the contours with green paint mixed with mineral spirits. This will solidify the drawing and the color will end up concealing the pencil lines.

The first brushstrokes cover the background, which is painted with violet mixed with white. The background is not covered completely. Some areas are left unpainted to allow the underlying color to breathe.

The colors of the fruit are not evenly applied, demonstrating how a single color can present variations. Rather than mixing on the palette, a small amount of each color is placed on the canvas and applied directly by dragging.

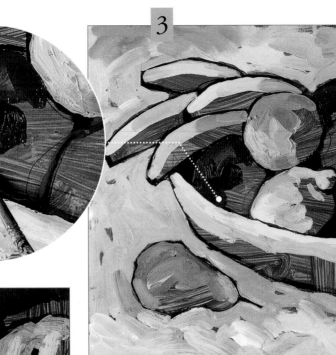

3

The illuminated areas of the fruit are painted with very saturated colors; adjust their intensity as you wish. Doing so gives the mango an orange undertone that has no relationship with the colors of the real fruit.

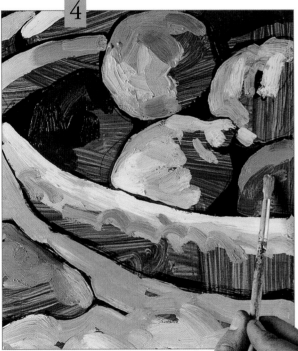

4

The lemon and the apple are painted with bright yellow and green respectively. As you can see, the shaded areas are left unpainted in anticipation of a new color. A thin round brush will make it easier to control the brushstroke.

Tip

The shadow colors should be luminous and saturated, not dark. Keeping the contrast confined to color will help you avoid creating too much tonal contrast.

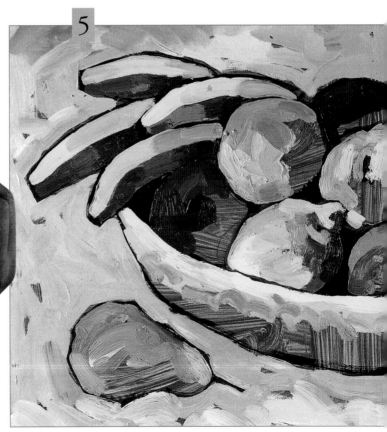

5

Once the lighted areas are complete, you can begin painting the shaded sides of the fruit. Begin with the yellow one, keeping in mind that violet is its complementary color. The color of the shadow should be applied evenly without gradations.

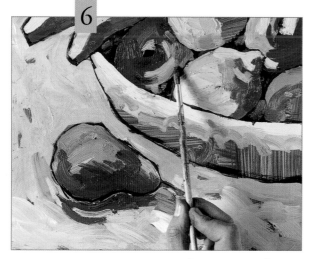

6

*Paint the shadows of the red apples (which are green)
and of the green pear (which casts a red shadow)
since these are complementary colors.*

*The texture of the wicker basket is
created by using the brush handle
to mark sgrafitto lines on a layer
of wet and thick paint.*

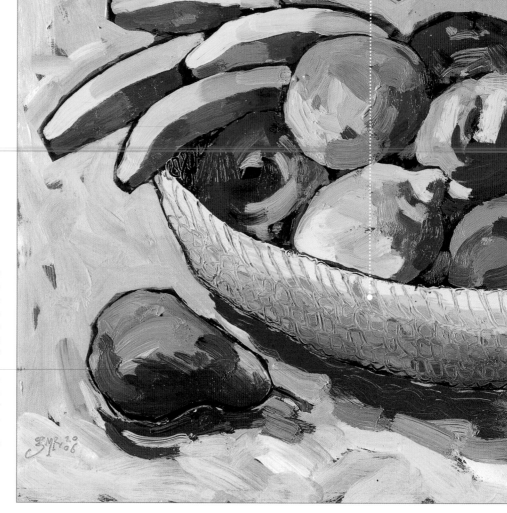

7

*The last step
is to paint the
shadows of the
mango and the
apple with blue
because blue is a
complementary
color to orange.
The same is done
with the base
of the wicker
basket. The
brushstrokes are
ample, thick, and
superimposed.*

PAINTING FRUIT *with a few* BRUSHSTROKES

Fruits and vegetables are traditionally the most lively and vital components of a still
life because they are natural elements. The artist can convey that vitality with a
thick brushstroke, controlling the direction and the mixture of colors on the support.
If you choose to work with washes, it is important to learn how to model and how
to give volume to the fruits with soft color transitions. Let's study both approaches:

1. *The first example shows an apple drawn with a graphite pencil. An approximation of its outline is sufficient.*

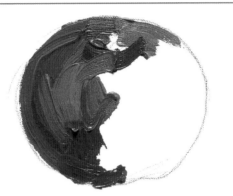

2. *The lighted area is resolved by accumulating paint with a brush of a variety of red, crimson, and orange colors. The paint is not mixed on the palette, but on the support.*

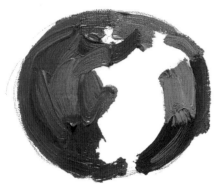

3. *On the opposite side, begin painting the shadows with viridian green reduced with a small amount of yellow and white.*

4. *In the center of the fruit the two colors are placed opposite each other. You should try not to mix them too much. The direction of the brush is printed vigorously on the paint.*

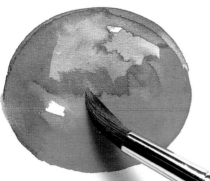

When you work with washes the brush marks are almost unnoticeable and the colors are mixed in transparencies.

The construction process for this tomato is very simple—it consists of two washes (gray and orange) slightly overlapped. Some of the brushstrokes depict the leaves. The white reserves represent the light reflections.

39

MODELING
and Chiaroscuro

MODELING *and Chiaroscuro*

In the classic approach to painting, modeling and shading in chiaroscuro are commonly used to highlight volume, emphasize roundness, or to convey the surface and tactile qualities of the objects that make up the still life.

Modeling and chiaroscuro take place in a scale that ranges from the darkest tone of the chosen color to the lightest; to apply them successfully the gradation effect is very important. This exercise, painted with oils by Óscar Sanchís, gives a nice example of this application.

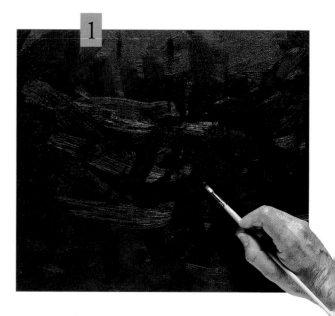

The artist draws the motif directly with a thin round brush charged with very dark violet brown. The forms are approximations, very sketchy, and constitute a simple profile.

This line study serves as starting point. Don't worry if it does not look perfect—the definite forms of the objects will be constructed as the colors are applied over the initial lines.

Tip

The background was painted a week in advance using very thick dark brown paint and leaving the brush marks visible. Painting over a dark background like this makes it possible to work the areas of light very effectively because the shadows retain the base color.

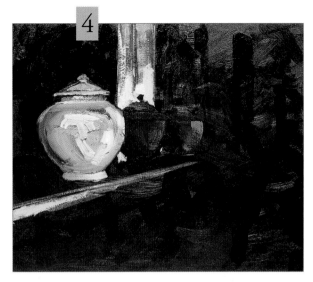

The first color areas of the earthenware are applied with a small household brush. This opens up areas of light that stand out vividly against the dark background. The brushstrokes should follow the rounded configuration of the surfaces.

The brushstrokes that are applied over the ceramic pieces will gradually become thicker as you go over them repeatedly, blending the different tones together. Use the same wide brush to apply the first highlights to the background.

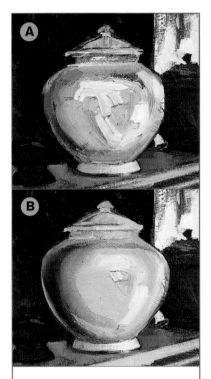

If you compare the two pots you will see the differences that exist between the areas painted with wide brushstrokes charged with thick paint (**A**), and the modeling effect (**B**), which eliminates the brushstroke marks and softens the colors with gradations (**A**). The round shape of the jar is created by dragging part of the lower tones with the brush.

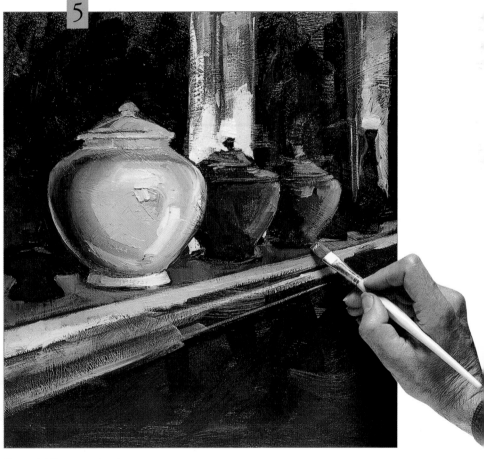

To model the ceramic pieces, use colors mixed with white and a small amount of mineral spirits. The greater the effect of chiaroscuro—the contrast between the areas of light color and the illumination—the greater the feeling of volume of the objects.

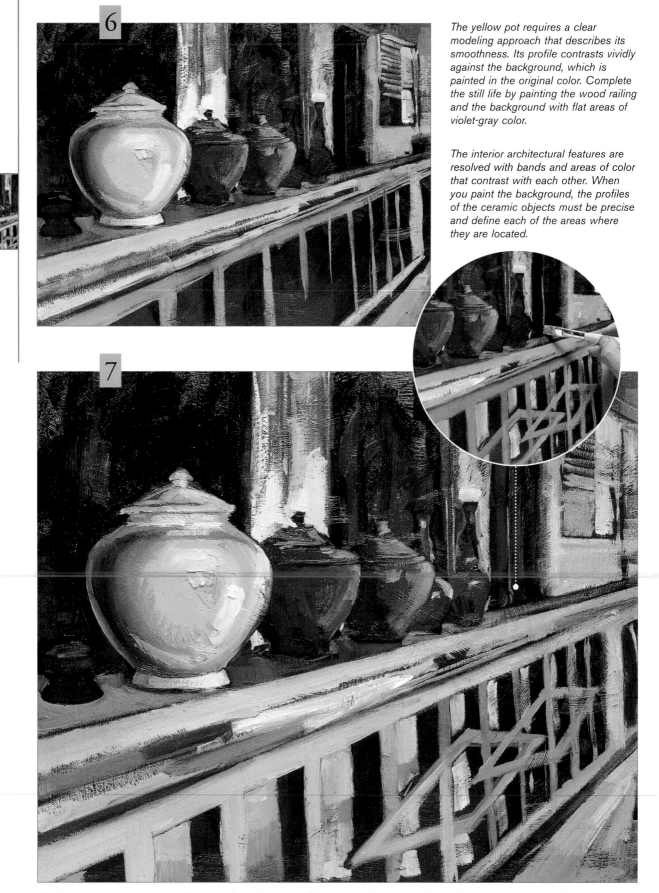

6

The yellow pot requires a clear modeling approach that describes its smoothness. Its profile contrasts vividly against the background, which is painted in the original color. Complete the still life by painting the wood railing and the background with flat areas of violet-gray color.

The interior architectural features are resolved with bands and areas of color that contrast with each other. When you paint the background, the profiles of the ceramic objects must be precise and define each of the areas where they are located.

7

The farther away the ceramic object, the flatter its color will appear and the less evident the contrast between light and shadow will be. The differences between the objects and the background are established through colors that are completely different and very directly applied without blending.

The IMPORTANCE *of* GRADATIONS

Knowing how to apply color and gradations when the paint is still wet on the support is very important for constructing the volume of the elements represented in the previous step-by-step exercise. In the following example we are going to practice the gradation effect to model the volume of a ceramic piece. It is similar to the previous exercise with two exceptions. In this instance the object is going to be addressed by itself and will be constructed on a white background rather than over a dark tone.

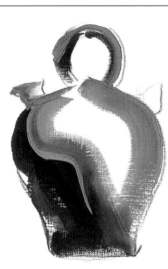

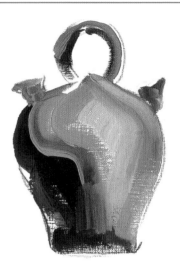

1. The outline of the ceramic piece is drawn with a pencil. The first applications of color will be dark brown for the shaded side. The paint is not diluted with mineral spirits to keep it thick and provide good covering power.

2. The lighted area of the piece is painted with ochre mixed with sienna and white. Apply the color with the entire width of the brush in a single stroke.

3. Using the rest of the ochre charged in the brush, finish covering the white part in the middle of the piece.

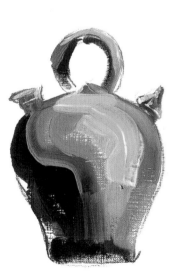

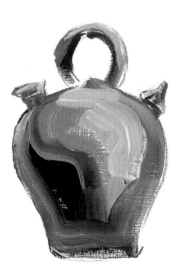

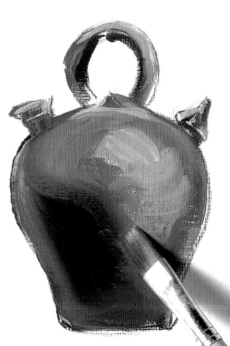

4. With the same ochre mixed with white, paint new areas of light on the upper elements of the ceramic piece. Paint the center of the object using the same color mixed with a small amount of yellow.

5. Go over the profile of the piece with the brush held clockwise. This allows the ochre to light up the dark brown that was covering the shaded area.

6. The volume of the object is finished by modeling the colors gently with a clean brush to form gradations, concealing any previous brush marks.

STILL LIFE
in SYNTHESIS

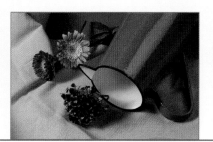

At the beginning of the exercise the artist should try to visualize the still life as a series of juxtaposed colors, without any details or texture. Here you will be synthesizing each part that presents several tones into areas of flat or blended color. By controlling the color, you create a puzzle of color blotches that acquires greater definition as the exercise progresses. If you continue with this approach to blocking in you will realize that constructing a still life is easier than it appears to be. This exercise was painted with acrylics and oils by Gabriel Martín.

The drawing must have a high level of synthesis for the flowers to be represented with simple circular shapes; they will be further defined when the color is applied.

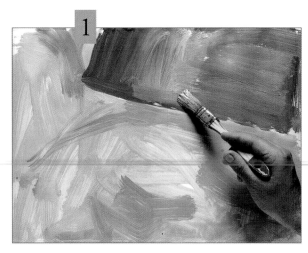

1

First, cover the white paper with large areas of ochre and violet acrylic paint, mixed with a small amount of white. A few gray brushstrokes provide variety to the large ochre area.

Tip

The drawing must be as simple as possible, bordering geometric. Adding detail is pointless since it will be concealed when the first colors are applied.

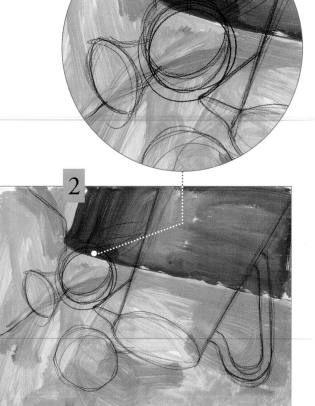

2

After waiting for a few moments for the first applications of acrylic paint to dry, define the model with a black oil pencil. The treatment is very simple and does not require details.

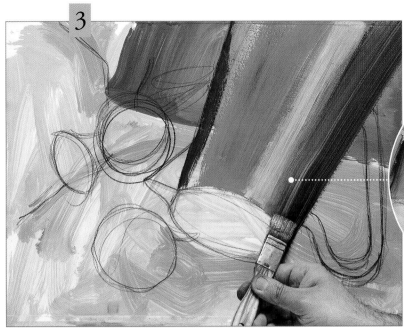

3

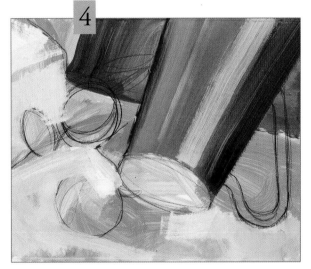

The maximum incidence of light is achieved by applying a large brushstroke of white tinted with green.

Using a household-type paintbrush that is a little bit wider than the previous one, paint the pitcher with viridian green and permanent green reduced with a little bit of ochre. Apply the brushstrokes diagonally to depict the reflections on the enamel surface. The brushstroke runs its entire length.

Tip

A wide household brush is very useful for painting with wide brushstrokes. It is impossible to use it to paint details, but it is a good tool for synthesizing.

4

With the tip of the wide household brush, paint several thinner linear reflections on the body of the pitcher. After cleaning the brush thoroughly, use white paint tinted with ochre and green to apply more paint to the tablecloth.

5

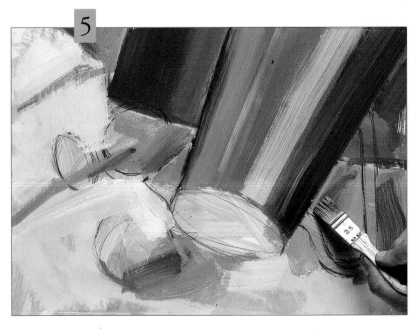

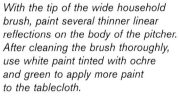

The artist has applied a gradation that further intensifies the color over the violet cloth. Apply the same violet mixed with ochre for the shaded areas of the light tablecloth.

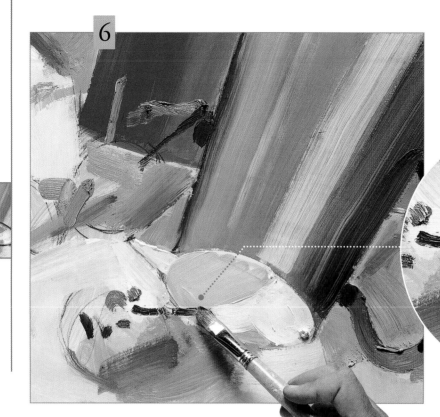

As the painting progresses, use the same brush to introduce some linear effects.

Using violet and white and a household brush, paint the interior of the pitcher. Next, use a medium-size brush with a flat tip to begin sketching the stems and the leaves of the flowers.

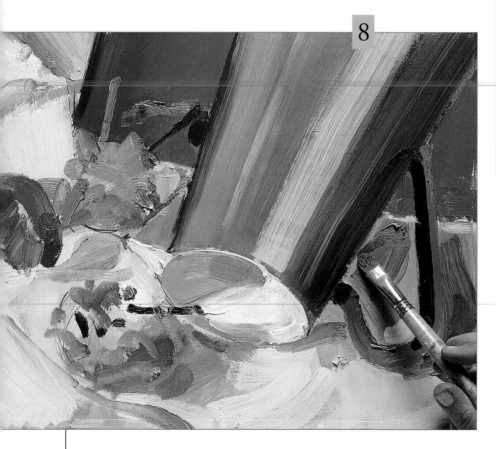

With the new brush, paint the handle of the pitcher with just two colors: bright violet and medium green. The paint should be thick, have good covering power, and be applied with a single stroke.

Charge the brush with pink tones achieved by mixing crimson, white, and a touch of yellow and ochre. Use very gestural brushstrokes to apply these colors to the flowers. The shadows on the tablecloth will be painted with ochre and a touch of violet.

The flowers are constructed by layering abstract shapes of color to create a unified effect. It would be impossible to try to re-create the shape of each petal exactly. Remember that we are synthesizing.

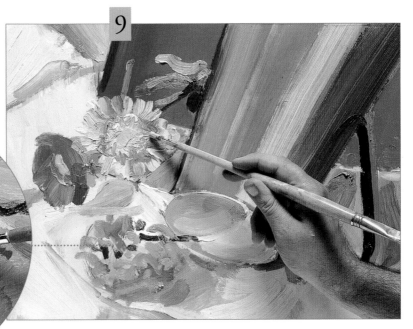

Thicken the paint on the flowers with pink colors in different degrees of brightness. The brushstrokes should be applied in the direction of the petals. Complete the shape of the petal by using the handle of the brush to draw on a thick paste.

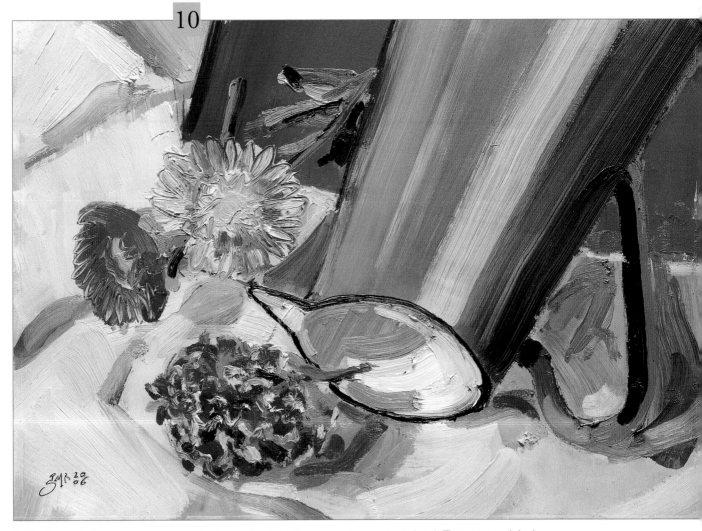

In the finished piece you can see the simple way in which the flowers have been painted. The stems and the leaves are barely insinuated with superimposed brushstrokes. To finalize it, paint a black line around the pitcher's upper rim.

Now, you will see how the previous exercise, painted by an artist, is interpreted by art students as part of their learning process. Even though the professional artist and the students have not painted the same model, you will notice that the students have applied the synthesizing process to understand the structure of the elements and to arrange the objects in such a way that the layout will look pleasing.

Different techniques and interpretations produce different results that are worth studying. Learning from the successes and ideas of these students will stimulate the progress of your own work.

Work by STUDENTS

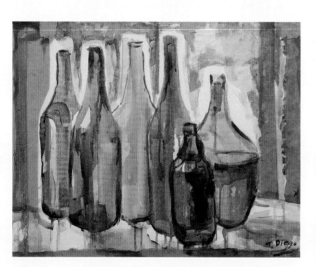

It is possible to create fresh and simple exercises like this one simply by using a group of conventional glass bottles. Color washes and transparencies give the bottles a certain lightness. The drawing of the bottle profile lacks precision and stability, which, in turn, makes the group more stable and vibrant. Strips of glued paper and paint drips make the painting look modernistic. Work by Teresa Diego.

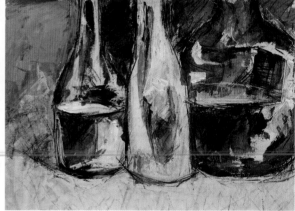

The layout of this composition is very interesting. It creates tension and breaks the compositional symmetry so visible in the previous example. The deliberate direction of the frame still allows easy identification of the elements represented, even though the student has created a piece in synthesis that borders on abstraction.

Painting with ample brushstrokes is completed with thin superimposed charcoal lines that define the form and provide texture to specific areas of the painting. Work by Carin Llauradó.

When the outlines of the bottles are highlighted with dark, thick lines and their volume is constructed with dense, opaque colors that have good covering power, the objects look heavy and solid. To counteract this effect, which in some cases can be counterproductive, the student has constructed bottles that look somewhat asymmetrical. The brushstrokes are very simple and do not depict details or textures. Work by Enrique Clapers.

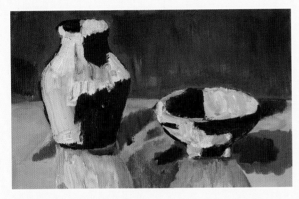

Monochromatic exercises are very appropriate for students as they require interpreting the model with a restricted color scheme. If, in addition, the student decides to work with large brushes, the synthesis process is complete. The results can look as clearly structured as this one. Work by Montserrat Carbonell.

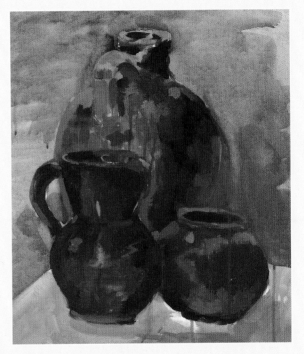

Here we have another monochromatic piece where the applications of color override the drawing—an approach that gives the ceramic pieces an asymmetric and whimsical look. It has been painted with only three colors: sienna, white, and black, mixed in different proportions. The areas of color look flat, opaque, and juxtaposed in an attempt to capture the exact light source in each area of the painting. Work by Teresa Diego.

Concluding our analysis is a presentation of a still life more informal in terms of composition and approach. In terms of composition, the piece stands out for its use of objects that are less academic and more casually arranged. As far as approach, take note of the use of newspapers for the collage and the combination of areas painted with a traditional chiaroscuro technique with others from the less formal, almost abstract, background. This gives the piece a very informal feeling. Work by Montserrat Castellà.

STILL LIFE *on*
a White Tablecloth

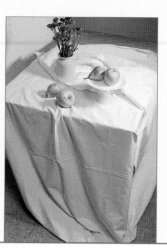

A few brightly-colored elements (a vase with flowers, a few apples, and a few pears) arranged carefully on a white tablecloth are ideal for studying the incidence of light, modifying the point of view, and very simply, but effectively, suggesting the fabric's folds and the way it hangs. The work is carried out with a household-type brush and another thin brush for the lines, taking advantage of the fluidity and transparency of watercolors. Painted by Manel Plana.

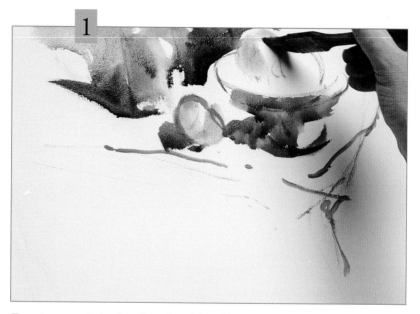

There is no pencil drawing. The edge of the table, as well as the shape of the fruit bowl and the fruit, are painted with a thin brush charged with a violet color. Without pausing, the first dark color applications are painted with a household brush.

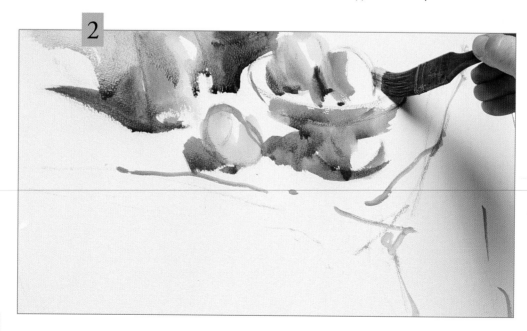

The dark areas of color are blended together, forming gradations. This is done by applying new colors over the previous layer while still wet. The main elements of the composition have been placed on the upper part of the painting, giving greater relevance to the drape of the tablecloth.

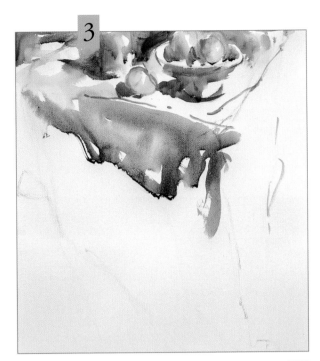

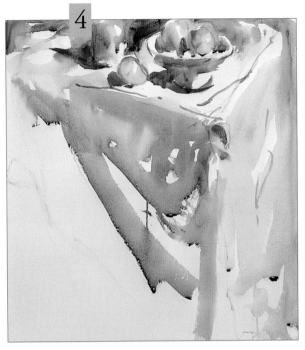

After the still life has been laid out with a household-type brush using brown mixed with a touch of violet, begin painting the tablecloth. This is done from top to bottom, beginning with the shaded area. The wash must be applied unevenly, leaving small unpainted white areas to depict the reflections of the light on the cloth.

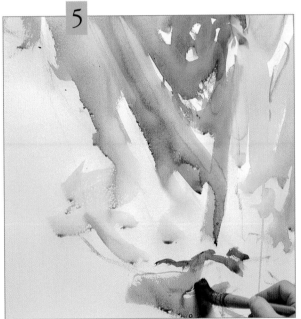

New brushstrokes give more flexibility to the cloth and help to show the direction of the folds. Do not consider the paint drips to be mistakes. On the contrary, they contribute greatly to the explanation of how the cloth hangs and to the spontaneity of the brushstroke.

When a tablecloth is painted with a brush charged with watercolors, you must understand that the brushstroke and the effects that come from it depend on the movement of the hand and the direction of the paper. The bristles on the brush must bend—and twist, if necessary—to achieve the desired effect.

Tip

To apply new washes over the previous ones, be certain to allow the latter to dry first. It is not a good idea to charge a wet wash with too much paint.

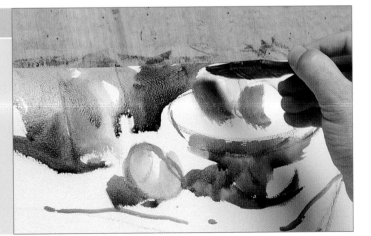

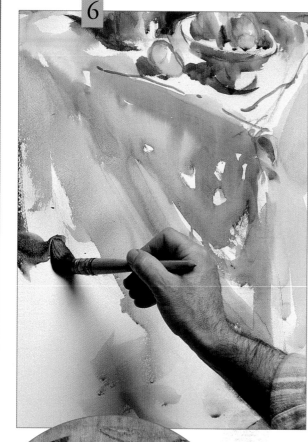

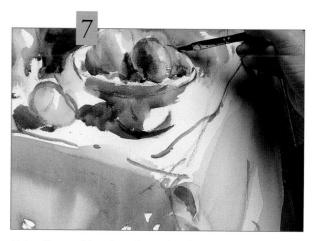

Using the small brush again, apply a few lines to help better define the form and the contrasts of the still life's shadows. These brushstrokes are done with Payne gray. Even at this stage, the still life has a very atmospheric effect.

Once the folds of the tablecloth have been painted with washes, wait a little until they dry. Then, again using the household brush charged with black and brown, paint the shaded area under the table. This will help define the inside profile of the white cloth.

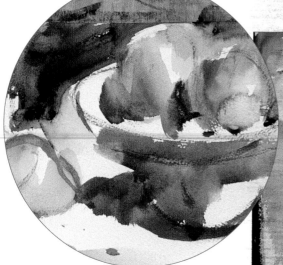

The reflections of light on the fruit are achieved by leaving some areas unpainted to show the white paper. This must be planned before the painting begins.

In the finished painting you can see the relevance of the space devoted to the tablecloth. The shaded area of the illuminated part of the cloth can be appreciated, thanks to the variations of the transparency of the wash. The still life, in some areas, is ghostly and unfinished looking, as is the vase, which is almost unnoticeable.

The IMPORTANCE of the DRAWING

Making a pencil drawing before each painting session is very useful because it will allow you to study the layout, become familiar with the objects, and to make decisions about the final arrangement and composition. Still life drawings have a low degree of difficulty when compared to other subjects that require greater discipline and precision, for example, drawing landscapes, figures, and portraits.

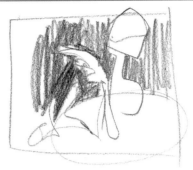

The best way to analyze and capture the model is to create a very schematic drawing. Only a few lines are required to situate the object, along with a couple of quick strokes for the shadows.

If you compare this sketch with the previous one, you will see how the point of view changes. You can then decide which one is the most suitable.

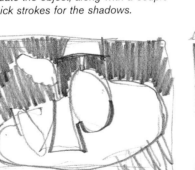

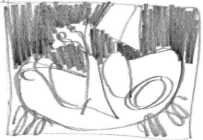

In this study, the level of distortion is even greater. The objects appear unfinished and the framing cuts off the upper part of the lamp.

After a few tests, this is the final version. The artist decides to cut off the lampshade and distort the table to make the composition more expressive.

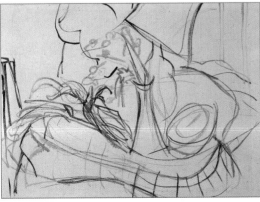

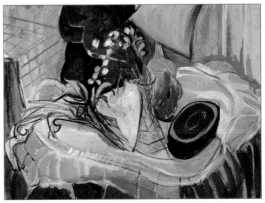

Starting with the previous sketch, the final layout is drawn on canvas with an oil pastel. The point is not to copy the drawing exactly, but to do an approximation. As you sketch, keep in mind that some things can be modified.

With the first applications of color on the painting, you can decide if the composition works. As the work progresses, this will be slightly modified. The important thing is to have a base on which to begin working.

Expressive BRUSHSTROKES

Composition with EXPRESSIVE BRUSHSTROKES

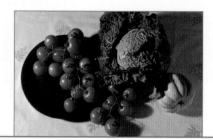

The interpretation of a still life is closely related to the way the paint is applied on the support. This treatment can include everything from areas of diluted color to thick concentrations of paste that give the painting a solid, expressive, and energetic appearance. This exercise will be carried out with a volumetric and heavy brushstroke, applying a series of warm colors in the most illuminated areas and blue tones in the shaded ones. This still life was painted with oils by Gabriel Martín.

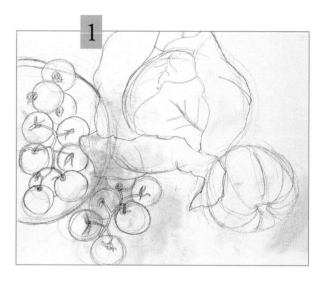

The best approach is to begin with a pencil drawing. It should show a very general layout of the composition; the details that further develop the forms will be added later.

Tip

The use of blue for shadows is always a good idea since it creates a strong contrast with the illuminated areas. Once the base is painted with an even layer of paint, it should be left to dry so the subsequent colors do not blend with the previous ones applied.

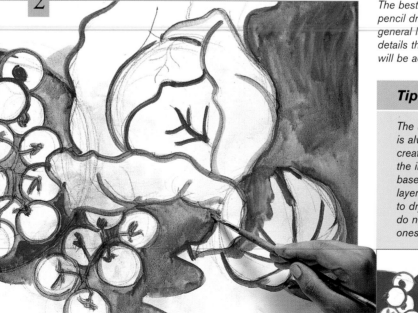

Using cobalt blue diluted with a generous amount of mineral spirits, highlight the outlines of the forms with a thick round brush. Next, using a medium brush, paint the shaded areas with blue.

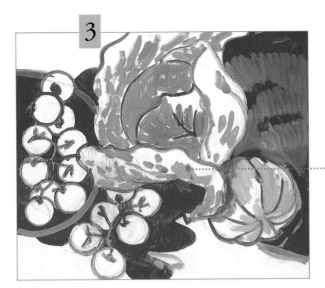

3

Work the denser and more covering colors without applying too much paint. Light blue should be the foundation for the cabbage and the pumpkin; the color is used as a background over which other colors will be added.

Several tints of blue are used in the first phase. These different tones make it possible to establish various shadow intensities and different planes.

Paint the tomatoes with red brushstrokes that are mixed on the support with yellow and ochre tones. The lower area of each one of them is defined with a line of saturated cobalt blue.

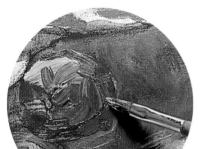

4

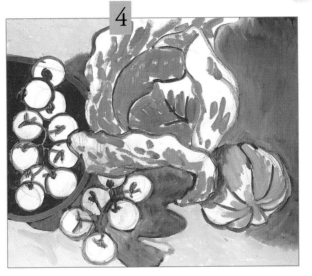

Paint the space that surrounds the elements with ochre beige. This way, you will create the first contrast between the illuminated areas and the shaded ones. Your main goal will be to cover, as soon as possible, the white support.

5

The tomatoes are resolved by applying gradations made of different colors. Using very thick paint, juxtapose a few brushstrokes of orange (for the areas of light), red (for the intermediate parts), and blues (only for the shadows) inside of the figures.

6

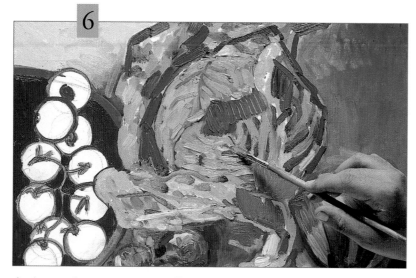

As the exercise progresses, you will work with thicker paint. This is where the value of the brushstroke, which should always follow the direction of each surface, becomes more evident. Using short directional brushstrokes of various tones will convey a greater dynamic feeling.

7

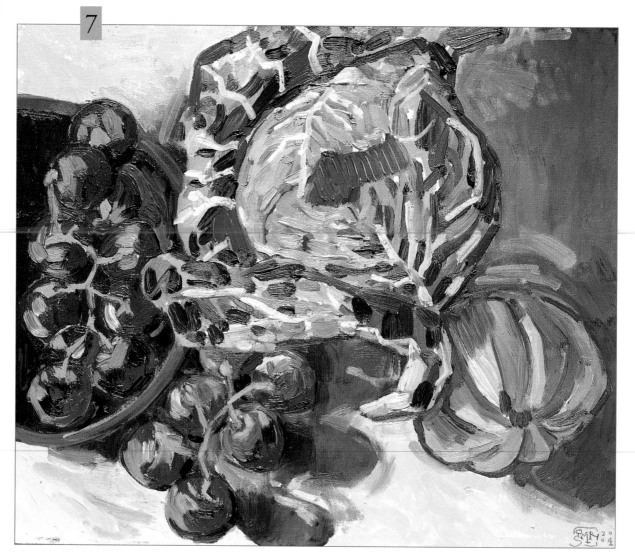

With thicker brushstrokes charged with more paint, define the texture of the cabbage by marking all the lines, crevices, and folds of the leaves. This contrast stands out when the color of the background is lightened.

HOW TO PAINT *the* PUMPKIN

You'll notice that in the previous exercise very little attention has been given to the pumpkin. There is a reason for this. We have decided to devote a special section to a more in-depth analysis of the most appropriate steps for painting its volume and expressing this element most effectively.

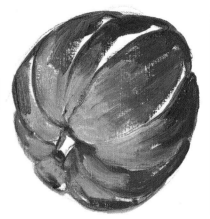

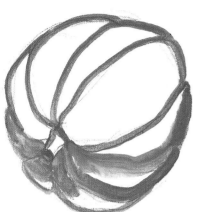

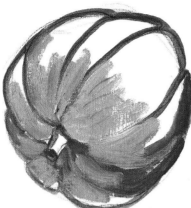

1. Over the pencil drawing that you made, highlight the main forms using a thin round brush and blue paint that is very diluted with mineral spirits.

2. Mix the previous blue with a small amount of white and ochre. Use the resulting color to paint half of each one of the sections. The brushstroke is no longer so diluted, but somewhat thicker and with more covering power.

3. Paint the bottom part of the pumpkin with a blue that is brighter and more saturated; halfway through, blend the previous light colors with the new applications of blue, forming a clear gradation effect.

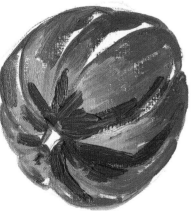

4. Cover the most illuminated area with orange red impastos. Apply each color with the brush tilted sideways to avoid dragging the color below the brush-line.

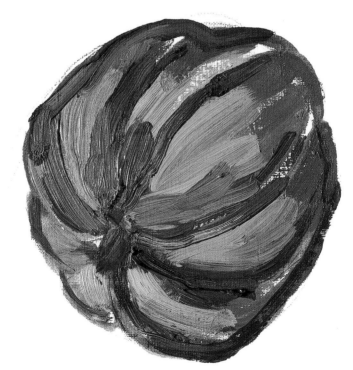

5. Complete the volume with new impastos of very light orange. Avoid touching the shaded areas to preserve the previous blue. To finish, paint the rounded lines that divide the surface of the pumpkin using the tip of a thin round brush charged with blue gray paint.

A CORNER
with Furniture

A CORNER *with Furniture*

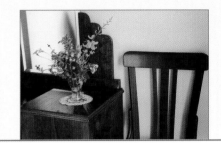

Furniture forms part of our daily surroundings and often provides artistic opportunities as the foundation or background to still life, and sometimes it even takes the lead role. Including furniture in still life allows you to create paintings that are greatly influenced by geometry. This exercise, painted with acrylics, utilizes a simple flower bouquet on a dresser. Next to it there is the back of a chair. Work by Esther Olivé de Puig.

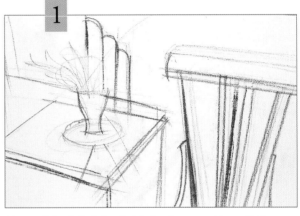

1

Use a stick of chalk to sketch the lines, working with the entire length of the bar against the surface. The drawing should not look too finished; you only want to lay out the main planes with lines that define the forms.

Now we apply the first colors to the furniture. The paint is dense. The idea is to cover each area with a monochromatic color, without modeling the forms.

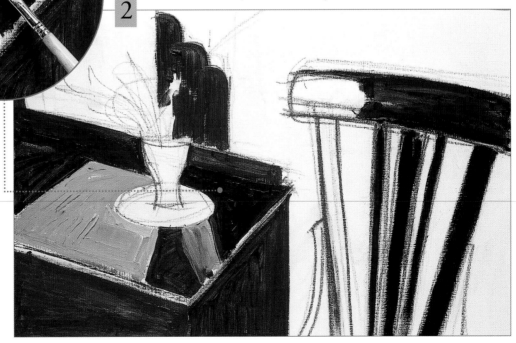

2

Mix the colors on the palette, adjusting the tones to those shown on the real model. It is important not to repeatedly brush the areas where two colors meet, to prevent the colors from blending together.

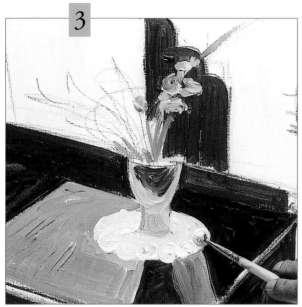

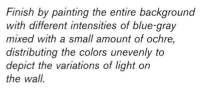

Finish by painting the entire background with different intensities of blue-gray mixed with a small amount of ochre, distributing the colors unevenly to depict the variations of light on the wall.

The areas of green, ochre, and brown tones are applied one after the other to complete the shape of the vase. Paint the doily with very thick white, letting the brushstroke create the form.

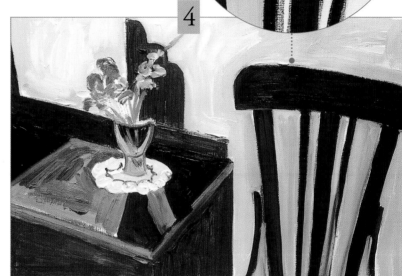

Paint the flowers in the vase with very direct dabs of thick paint. The movement of the brush shapes the petals. The background is covered with a grayish tone and the chair with blue-black.

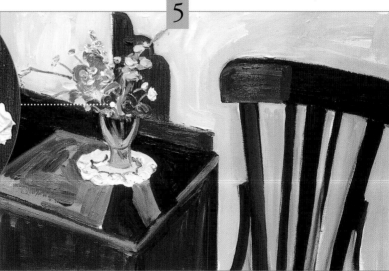

In this detail you can see how the artist has applied the brushstrokes to create the flowers. The different brushstrokes form curves and crossed lines that depict the petals and the direction of the leaves and the stems.

Darken the surface of the dresser with new applications of sienna, ochre, and umber. Once the bouquet of flowers is finished, paint the glass surface with a gray similar to that of the wall (although a little more yellow).

Tip

Work the shadows with blue and violet colors. Each change of color corresponds to different degrees of shadow. The direction of the brushstrokes used to depict the shadows runs parallel to their respective objects.

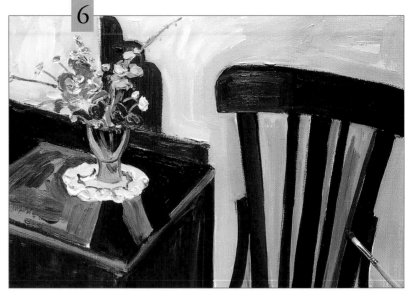

Use long and covering strokes to paint the contrasts of the chair. Lighten the most illuminated areas of the chair back with blue and paint the shadows projected by it on the wall with violet.

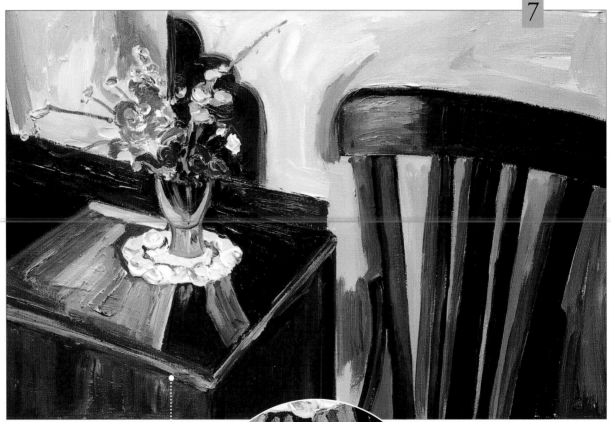

Until now, each plane of light on the dresser has been worked with colors that are different from the rest. To finish it, add more shadows, blends, and gradations to mimic the smooth and shiny surface of the wood.

Each tonal change on the furniture is done with direct brushstrokes, allowing the colors to blend together. The brushstrokes should have greater contrast and emphasis in the areas where there are more light reflections.

The MIRROR EFFECT

Placing a mirror, a door, or a window behind a composition gives more depth to the still life, a genre that is typically confined to a tight space. Although many amateur artists may think that adding a mirror with all the difficulties presented by its reflections may complicate the model, in this section we will show that its reflective surface can be created with a few brushstrokes.

The mirror is like a window that opens behind the still life, giving new spatial dimension to the model. The drawing can be linear, just like any other element of the drawing.

What changes is the way the elements that are reflected on mirror are painted. The real objects must have brighter colors and well-defined contours. The reflected image has a bluish tone and things appear more distorted.

The way the surface of a mirror is treated is very similar to this one, with a general blue tone, smooth changes in color, and directional brushstrokes that give the piece a casual look.

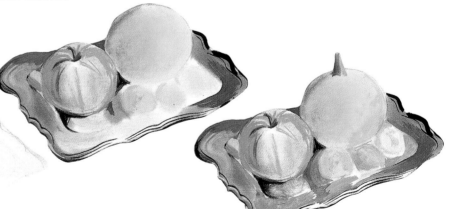

1. Let's analyze another example that demonstrates how to represent the reflection of an object on a smooth surface in three stages. In this case, it consists of a couple of pieces of fruit placed on a metal tray.

2. The profile of the tray is painted with gray tones. The area of reflection is left white; the rest is covered only with gray, which represents the shaded area between the two pieces of fruit. A couple of white spots with a slight yellow tint indicate the area of reflection.

3. The reflected objects are represented on the tray in reverse. The colors of the reflection are somewhat darker than the real model, with a gray undertone. The reflection is very spontaneous and has very little definition.

Model for ABSTRACTION

STILL LIFE *as a* Model for ABSTRACTION

We close the exercises by opening a door to abstraction. We zoom into the model, a bowl containing many vegetables, and limit the layout to very few forms without any spatial depth. This way, the profiles will look unfinished and the contrast will be achieved through color. This will let us work with a sketchy drawing that is not very defined, and allow the saturated colors to stand out more. This still life was painted with acrylics by Almudena Carreño.

Make a pencil sketch of the circular shapes of the fruits. Next, paint the inside of each piece with warm colors that range from magenta to yellow and red. The colors are mixed to form gradations.

Cover the white paper quickly with a magenta base, mixed with a small amount of red. You must work fast because the paper absorbs the paint and it dries very quickly.

The tonal range used is quite harmonious. When you wish to contrast the profiles or the forms, you must juxtapose violet with orange yellow. To darken the violet color you can mix it with a touch of brown sienna.

3

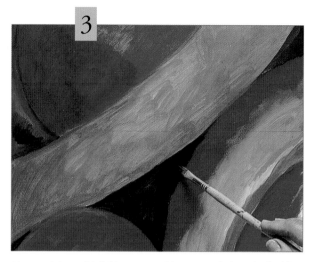

Use a mixture of bright green and brown to darken the insides of the forms and the shaded areas that appear between the fruit. Work these areas with a medium round brush.

To finish the painting, forget the real model completely and let your imagination add new circles, colors, and lines that will give the piece greater interest. This way, what started out as a still life has become an abstract composition.

4

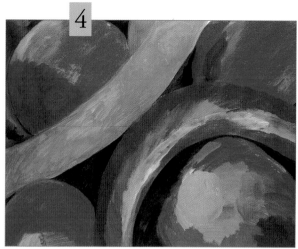

To keep the onion on the lower part from getting too close to the pepper, paint the profile again with a very dark violet. If the spaces between the vegetables are darkened, the forms will have more contrast and definition.

Use a loaded brush to accentuate areas of contrast along the outlines and to describe the shapes of the various forms. This will heighten their decorative effect, as illustrated here by the wavy lines used to describe the pepper.

5

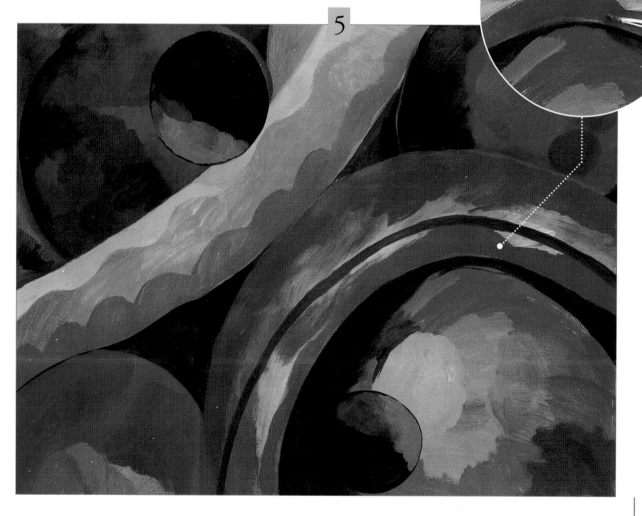

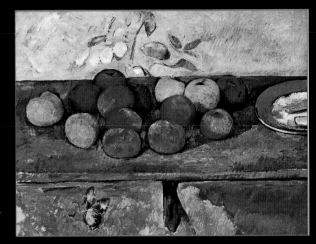

*Paul Cézanne,
Still Life with
Apples and
Biscuits,
1879–1882.
Oil on canvas,
18 × 21½ inches
(46 × 55 cm).
Musée de
l'Orangerie
(Paris).*

PAUL CÉZANNE
(1839–1906)

*Paul Cézanne, Self Portrait Outdoors, 1873–1876. Oil on
canvas, 25 × 15 inches (64 × 38 cm). Musée d'Orsay (Paris).*

No nineteenth-century artist has been so
passionately devoted to painting still life as
Cézanne. He preferred this genre among other more
popular ones such as landscape or the figure, which
he also painted, perhaps driven by his introspective
spirit and his love for home life. Just a few objects
and some pieces of fruit were enough for him to
create a piece of great refinement and value.

The passion that Cézanne felt for still life is evident
in a letter that he wrote to his friend Gasquet, from
which we quote: "Look, what I have not been able to
attain so far, what I feel that I will never be able to
attain with the figure, with portraits, I may have been
able to get closer to here . . . in these still lifes." The
main element and focus of his still life was fruit, for
which the painter felt a special predilection. As he
said, "I have given up flowers. They wilt right away.
Fruit is more loyal." We attribute this preference to
several reasons: their compositional value, their
simplicity, their texture, and the life force that they
were capable of conveying. "When the skin of a
beautiful peach, the melancholy of an old apple is
reproduced with heavy brushstrokes, one can see
halfway through the reflections that exchange the
same faint hint of surrender, the love for the sun,

the same memories of the morning dew…" Cézanne's
still lifes are characterized by their very simple
compositions, which are at the same time complex in
form and color. "There is no line, there is no modeling,
there is only contrast. When color arrives at its richest
point, then form reaches its fullness (…). Colors
constitute nature's life, the life of ideas." Color almost
becomes the only structural element of the painting:
"I was happy with myself once I discovered that one
has to make represensions through something very
different, through color as such. Nature should not
be represented but created through structuring
chromatic equivalents." The secret of representation
resides in the application and fusion of colors on
canvas that he created by vigorously painting with the
brushes, even with the hand, to achieve an interesting
optical effect with the distance. "Exposed to full light,
on porcelain plates or on white tablecloths, one can
see pears and apples painted with ample strokes
and modeled with the thumb: seen from close up,
the painting looks like a chaotic mixture of bright red
and yellow, green and blue. But if one keeps the
adequate distance, they become succulent and juicy
fruits that awaken the appetite. And all of a sudden
one can see."

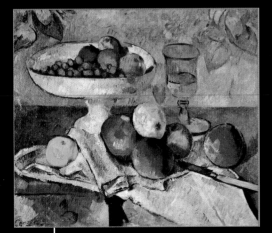

*Paul Cézanne,
Still Life: Fruit
Bowl, Glasses,
and Apples,
1879–1880.
Oil on canvas,
18 × 21½ inches
(46 × 55 cm).
Private Collection
(Paris).*

*Paul Cézanne, Still Life: Fruit, Napkin, and Jug of Milk,
1879–1882. Oil on canvas, 23⅝ × 28¾ inches
(60 × 73 cm). Musée de l'Orangérie (Paris).*

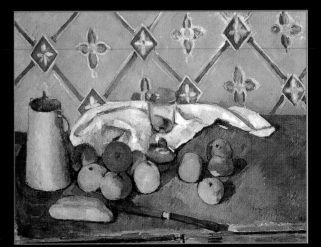